**The Robert
and Jane Meyerhoff
Collection**

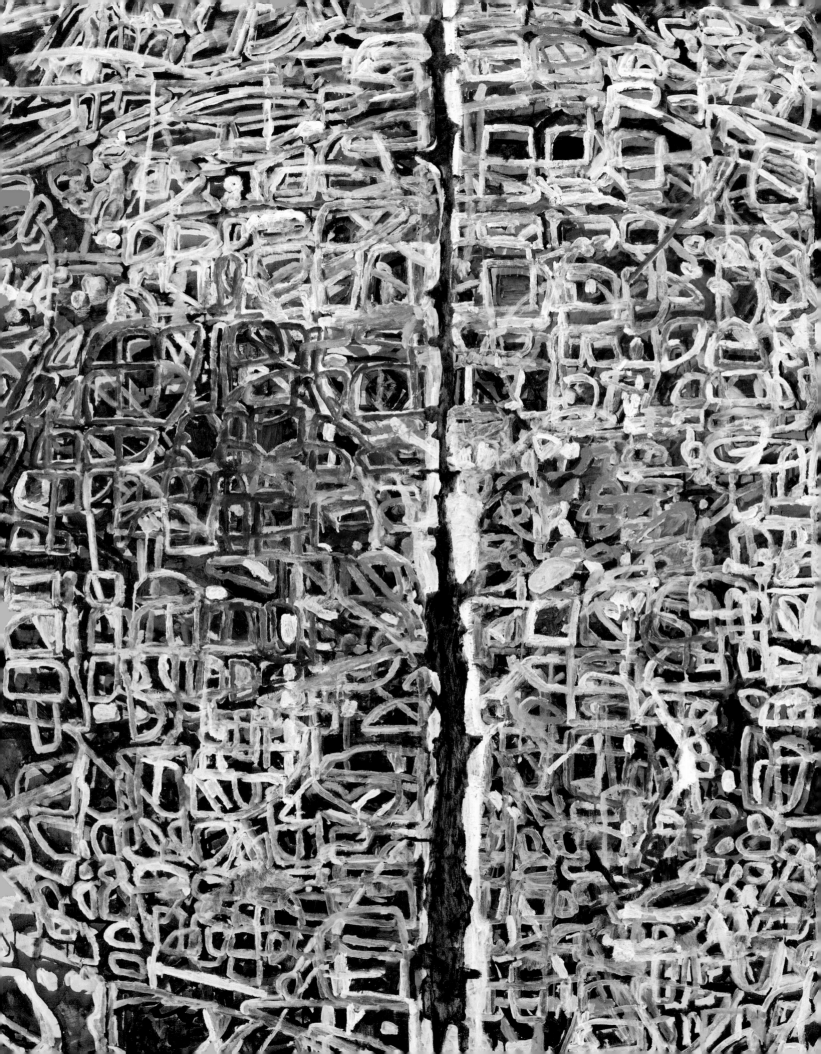

The Robert and Jane

Meyerhoff

Selected Works

Collection

Harry Cooper

National Gallery of Art,
Washington,
in association with
Lund Humphries

The exhibition was organized by the National Gallery of Art, Washington.

National Gallery of Art
October 1, 2009–May 2, 2010

Produced by the Publishing Office, National Gallery of Art, Washington, *www.nga.gov*

Judy Metro, Editor in Chief
Chris Vogel, Deputy Publisher and Production Manager

Designed by Margaret Bauer
Edited by Susan Higman Larsen

Typeset in Myriad Pro and Minion. Printed on 150 gsm Phoenix Motion Xantur at Legatoria Editoriale Giovanni Olivotto in Vicenza, Italy.

Photographs, Division of Imaging and Visual Services, National Gallery of Art, Washington. Alan Newman, Division Chief; Lorene Emerson, Head of Photographic Services; photography: Greg Williams, Lee Ewing, Ricardo Blanc, Dean Beasom, Ken Fleisher, Debbie Adenan, Christina Moore

**Library of Congress
Cataloging-in-Publication Data**

National Gallery of Art (U.S.)
The Robert and Jane Meyerhoff collection : selected works /
Harry Cooper.

 p. cm.

Catalog of an exhibition organized by and held at the National Gallery of Art, Washington, D.C., Oct. 1, 2009–May 2, 2010.

Includes bibliographical references and index.

ISBN 978-1-84822-050-8

1. Painting, American — 20th century — Exhibitions. 2. Meyerhoff, Robert — Art collections — Exhibitions. 3. Meyerhoff, Jane — Art collections — Exhibitions. 4. Painting — Washington (D.C.) — Exhibitions. 5. National Gallery of Art — Exhibitions. I. Cooper, Harry, 1959– II. Title.

ND212.N33 2010
759.06074'753 — dc22 2009018946

Published in association with
Lund Humphries
Wey Court East, Union Road
Farnham, Surrey GU9 7PT, UK, and
Suite 420
101 Cherry Street
Burlington, VT 05401-4405, USA
www.lundhumphries.com
Lund Humphries is part of
Ashgate Publishing

Display images:
page ii: Terry Winters, *Graphics Tablet* (detail), cat. 92
page vi: Jackson Pollock, *Untitled* (detail), cat. 70
page 1: Willem de Kooning, *Untitled VI* (detail), cat. 5

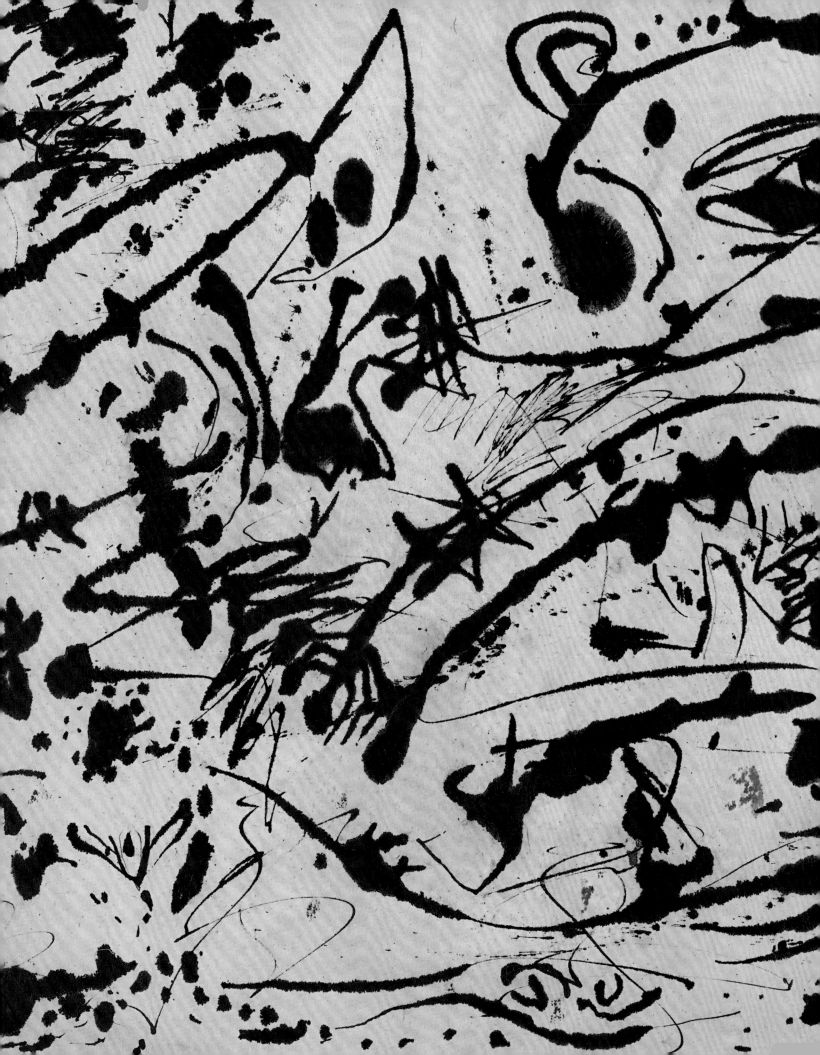

It is a cliché to talk about the eye of the collector, but it is hard to avoid in the case of Robert and Jane Meyerhoff. From their first purchase in 1958 until Jane's untimely death in 2004, the couple built one of the greatest collections ever to focus on American painting of the postwar era. Over five decades, they acquired almost three hundred works of art, and not once did they use an adviser — just their own eyes.

A stroll through the galleries of the East Building reveals at every turn the great debt that the National Gallery of Art owes to the generosity of the Meyerhoffs. Their first act of philanthropy came in 1986, when they funded the purchase of Barnett Newman's masterpiece, his fourteen *Stations of the Cross,* and the related painting *Be II.* In 1987, the Meyerhoffs agreed that their own collection would eventually find its permanent home here. Since then, their gifts to the nation have numbered nearly fifty works, including major pieces by Clyfford Still, Claes Oldenburg, Joseph Cornell, Josef Albers, Roy Lichtenstein, Jean Dubuffet, Grace Hartigan, William Baziotes, Bradley Walker Tomlin, Hans Hofmann, and Mel Bochner. Recently, I was pleased to announce that the Meyerhoffs' beautiful home and galleries near Baltimore would also figure in the donation, as an off-campus facility for the exhibition and study of art.

Needless to say, all this has not only formed the cornerstone of our collection of modern and contemporary art; it amounts to one of the most significant gifts ever bestowed on the National Gallery, and for that we are deeply grateful.

This presentation of the collection of Robert and Jane Meyerhoff will be both familiar and unfamiliar to those who recall its first showing at the National Gallery in 1996. At that time, visitors had the opportunity to see almost the entirety of the collection. The present exhibition is more selective (although it should be noted that more than 20 works already donated by the Meyerhoffs will remain on view elsewhere in the East Building), and the selection is different. Of the 126 works shown here, 24 were not included in the first exhibition, including numerous prints and drawings

in particular. But above all, the organization is different: the earlier exhibition was arranged by artist; this one divides the collection into ten themes, probing the visual logic behind the choices made by the collectors and by the artists they collected.

This scheme was developed by our new curator of modern and contemporary art, Harry Cooper. His essay in this volume constitutes an engaging analysis of the principal themes and devices of modern art as told through the Meyerhoff collection, together with selected earlier examples from our own permanent collection. This reflects the seamless way in which the Meyerhoffs' collection complements and extends the National Gallery's superb examples of early twentieth-century art.

It was my privilege to know Jane Meyerhoff, and it has been my continuing pleasure to work with Robert Meyerhoff for many years now. Collecting for them was a visual, intellectual, and intensely personal affair, a consuming labor of love that involved building close relationships with many of the principal figures of American art and getting to know their work from the inside out. Accordingly, they acquired more in depth than in breadth. Their collection was built around six major figures — Jasper Johns, Ellsworth Kelly, Roy Lichtenstein, Brice Marden, Robert Rauschenberg, and Frank Stella—and it has always been shown that way. Our decision to present it so differently this time, therefore, constitutes a radical departure, although it is one (as I understand from Robert) that Jane herself sometimes imagined but never realized. We hope that she would be pleased with this exhibition, which we dedicate to her memory, and — on behalf of her and Robert — to the nation.

Earl A. Powell III, *Director*

An exhibition of this magnitude requires the efforts of many people, and I begin by thanking Earl A. Powell III, director of the National Gallery of Art, and Franklin Kelly, deputy director and chief curator, for their unswerving support. The groundwork for this exhibition was laid prior to my arrival at the Gallery in February 2008 by Judith Brodie, our curator of modern prints and drawings, and Leah Dickerman, our former associate curator of modern and contemporary art. I am grateful to them and to my fellow curators Molly Donovan, Charles Ritchie, and Lynn Matheny. Sydney Skelton, my curatorial staff assistant on the exhibition, coordinated all its aspects with consummate skill, conducting research on the collection and organizing the exhibition materials and paperwork with help from Alexandra Gregg.

Our registrar's office expertly transported the works of art, which posed considerable challenges. Lehua Fisher and Michelle Fondas managed the effort under the aegis of Sally Freitag and with a team of art handlers led by Robert Cwiok and David Smith. Mark Leithauser, chief of design, and architect Jamé Anderson gave my ideas for the exhibition an inspiring and concrete form, with help from Linda Daniel. In the conservation division, Jay Krueger, Katy May, Hugh Phibbs, and Jenny Ritchie, among others, ensured the proper care and presentation of the works of art, including restoration, cleaning, and framing, as needed. D. Dodge Thompson, head of the exhibitions department, took charge of important administrative details with Wendy Battaglino. I would also like to thank Deborah Ziska and Anabeth Guthrie in the press and public information office, who promoted the exhibition, and Faya Causey and Ali Peil in the department of academic programs, who enriched its experience.

Production of this catalogue was accomplished with speed and grace by Judy Metro, our editor in chief, and her team, including deputy publisher Chris Vogel, freelance editor Susan Higman Larsen, assistant production manager John Long, photography rights coordinator Sara Sanders-Buell, and program assistant Daniella Berman. I am indebted as well to Yve-Alain Bois and Sarah Boxer for their helpful comments on my texts. The stunning catalogue design is the work of Margaret Bauer, who, in addition to composing the graphic elements of the book, advised on the ordering and juxtaposition of the plates, which constitute a kind of exhibition of their own.

A major effort to ensure the best possible photography of the art was organized by Lorene Emerson under the supervision of Alan Newman, head of the Gallery's imaging and visual services department, and with assistance from Kenneth Fleisher, Debbie Adenan, Christina Moore, and Peter Dueker. Photographers Lee Ewing, Greg Williams, Dean Beasom, and Ricardo Blanc provided new images of the highest quality.

I wish to offer my deepest thanks to Robert Meyerhoff for agreeing to part with so much of his art for the lengthy run of this exhibition, and for being so very accommodating during its preparation. The hours I spent looking at the collection with him and learning about its history were memorable. His staff members Jeanette Preston, Charles Schlauch, Denny Greensfelder, and Kevin Reithlingshoefer provided assistance along the way. A final debt of gratitude is reserved for the late Jane Meyerhoff, whose keen eye, sharp mind, and demanding spirit set the standards for this exhibition. I trust we have met them.

Harry Cooper, *Curator of Modern and Contemporary Art*

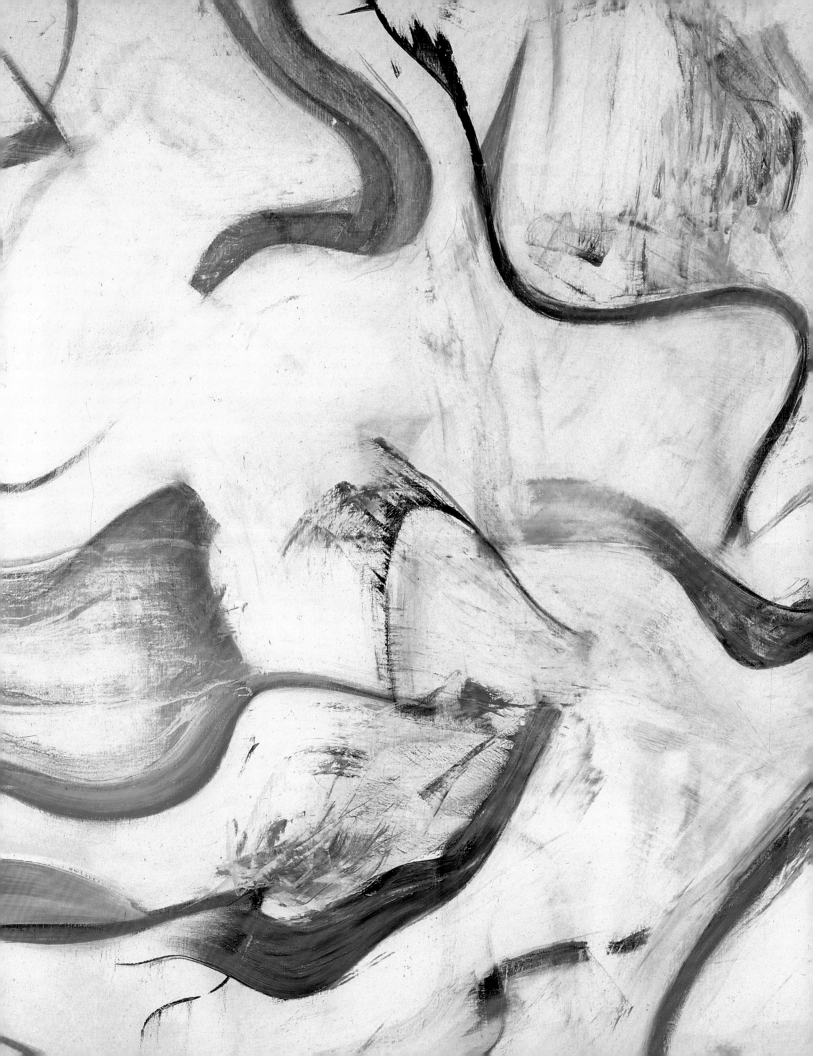

I think I see . . .

HARRY COOPER

THE FRONT COVER of this volume makes reference to the Meyerhoff eye. It is, quite appropriately, a hidden reference, requiring visual discovery. (Take a moment to find it.) On the back cover, the absent protagonist in a drawing by Roy Lichtenstein stammers, "I . . . I'll think about it!" — as if that personal cry had to fight to be heard through the impersonal media of the Ben-day Dot and the 1950s comic strip. The repeated "I" in the word balloon, taken together with the trick on the front cover, suggests a pun: I = eye. That pun has a famous lineage. "I become a transparent eyeball; I am nothing; I see all," wrote Ralph Waldo Emerson in "Nature" (1836) about being alone in the woods. In a fantasy of pure (in)visibility, the eye, that regal organ for Emerson, replaces the I.

It is a seductive fantasy. *All you need is an eye. Trust your eye.* These are mantras of art collecting, but they are too simple for the Meyerhoffs, whose procedure was more than just intuitive and visual; it was reflective. Take the most basic, global fact about the collection, namely, that the six artists who dominate it are split between those committed to abstraction — Ellsworth Kelly, Frank Stella, Brice Marden — and those who rarely relinquish the figure — Robert Rauschenberg, Jasper Johns, Lichtenstein. This even-handed transgression of one of the great divides of twentieth-century art suggests a method of provocation and, certainly, deliberation. Reading, note taking, and long discussions, often with the artists in question, preceded the collectors' decisions.

In the end, the Meyerhoff collection gives our eyes plenty to think about. What visual logic could have led to the cohabitation, as on these covers, of the heroic gestures of Franz Kline and the cool ironies of Lichtenstein? Let us recall just how contested the field of American art was

during most of the time that the Meyerhoffs were collecting. The critical landscape was divided, to put it only a little too simply, between the formalism of Clement Greenberg, the existentialism of Harold Rosenberg, and the pluralism of Leo Steinberg. The leader into the 1970s was Greenberg, whose later writings, perhaps taking Emerson's fantasy of a transparent eyeball too literally, made opticality the *sine qua non* of aesthetic quality. In the work of abstract expressionists Clyfford Still, Barnett Newman, and Mark Rothko, Greenberg discovered a pictorial space so devoid of normal cues about depth that only a disembodied eye could imagine entering it. Almost every up-and-coming artist defined himself or herself in relation to this orthodoxy, whether in alliance (e.g., Kenneth Noland), ambivalence (e.g., Stella), or opposition (e.g., Johns).

The Meyerhoffs not only collected all along this Greenberg scale, to coin a phrase; they violated the prior divide that he and others had established within abstract expressionism, collecting both the "gestural" side championed by Rosenberg (primarily Willem de Kooning and Kline) and the "field" painters whom Greenberg saw as progenitors of opticality. Nor did they neglect the less heroic, more lyrical side of the school: Mark Tobey, William Baziotes, Bradley Walker Tomlin, Grace Hartigan, and Hans Hofmann.

This breadth was not a mere function of changing focus over the years. The Meyerhoffs' first purchases, twenty or so works acquired between 1958 and 1970, included not only art by Noland, Stella, and Anthony Caro — unsurprising choices given that Greenberg's unruly disciple Michael Fried championed them — but also three works by Rauschenberg, which was remarkably prescient. They bought *Tour* (cat. 126) from the virtually unknown artist

in 1959. First purchases also ran the gamut of abstract expressionist work: de Kooning, Rothko, and Jackson Pollock, as well as the lyricists. The pace of collecting picked up in the 1970s with about twenty-five pieces, including first acquisitions of work by the four other figures who, in addition to Rauschenberg and Stella, would become principals in the collection: Kelly (*Orange Green;* cat. 118), Marden (*Cogitatio;* cat. 82), Lichtenstein (*Girl with Beach Ball III;* cat. 67), and Johns (*Night Driver;* cat. 103). Then came an explosion of activity, about seventy-five acquisitions in the 1980s, when the Meyerhoffs built depth in these six major figures but also added new artists to the roster, from Andy Warhol to Ad Reinhardt, from Barnett Newman to Howard Hodgkin.

What did it mean to collect this range of artists? For one, it meant that the Meyerhoffs did not take the critical disputes of the day any more literally than did the artists themselves. Stella drew equally on, and equally resisted, the examples of Johns and Noland. De Kooning credited Pollock with "breaking the ice" and would have been hard pressed to say which one of them was a field painter, which a gesture painter.[1] (It's still not obvious.) This is not to say that the Meyerhoff collection is a broad survey. Major figures that one might expect to find in a collection focusing on postwar U.S. painting, such as Cy Twombly, Joan Mitchell, Alex Katz, Robert Ryman, Morris Louis, and others, are absent.[2] While it is tempting to speculate why, the point is that breadth alone does not explain the diversity of the collection. It is not a survey. Rather, there must have been a visual logic, or logics, at work.

A visual logic, a thinking eye.[3] Such phrases make me think, first, of Paul Cézanne's statement to Emile Bernard: "Within the painter there are two things: the eye and the brain." Bernard decided that Cézanne was more brain than eye (ignoring his effort to coordinate the two), and Pablo Picasso reportedly drew a similar conclusion later, suggesting that it was Cézanne's influence that led him to ask "if we should not represent the facts as we know them rather than as we see them."[4] The eye-brain distinction is useful in thinking about the Meyerhoff collection, in a surprising way. Of the six main artists, the three abstract ones are, arguably, more in the "eye" camp, the three figurative ones more in the "brain" camp. This crossing reflects, on the one hand, the long engagement of abstract art with the structure of visual experience, and, on the other, all the nonretinal ways (language, collage, imprint, reproduction of various kinds) that the visible world has entered art since the cubist revolution. It is a salutary confusion of categories.

I also think of Rudolf Arnheim, the Harvard professor and author of *Visual Thinking* and other works, who combined perceptual psychology with formal analysis in the years that the Meyerhoffs were collecting.[5] Although a book by Arnheim (*The Power of the Center,* 1983) suggested one of the ten categories that follow (Concentricity), his approach will serve me less as a model than as something to resist. Because of his embrace of Gestalt psychology, he treated the work of art more as visual image than as material object, and he saw the perceptual work of discriminating a figure against a ground as basic to aesthetic appreciation. By contrast, I am just as interested in the physical base of a painting, its materials and processes, as in its perceptual superstructure, its image — and so, I would argue, were many of the Meyerhoff artists. And many of them, rather than relying on the distinction of figure and ground, struggled to break it down in pursuit of abstraction and

all-over structure. Finally, if (like Arnheim) I am drawn to formal analysis, I am also interested in how art reflects on its conventions and habits, its own formality.

The ten divisions of this essay, and of the exhibition, reflect these interests. They range from the physical and material (e.g., Scrape, Drip) to the perceptual and formal (e.g., Line, Concentricity) to the more self-reflexive and philosophical (e.g., Art on Art, Picture the Frame). There is some arbitrariness in these choices — Shape, Layer, or Cut might have worked as well — and in the assignment of any given work to one category or another. (The only rule in choosing the categories was that each accommodate as many different artists as possible.) The choices reflect a bias toward the formal as opposed to the iconographic or contextual, and yet one of the traditional goals of formal analysis, to understand the development of individual oeuvres — a goal admirably met by the National Gallery of Art's 1996 catalogue of the Meyerhoff collection — will not be pursued.

What, then, is the payoff in this remix of the collection? First, it will raise many of the principal issues in post-war painting, allowing us to detect, if not a singular logic behind the whole collection, then at least the multiple logics that animated the work of modernism in and on these categories. To show how this work reaches back to the beginnings of the twentieth century, each of the ten sections that follows will begin with a pre-1945 work from the National Gallery of Art's permanent collection. Second, in breaking with standard models of organizing a collection — by artist, chronology, or medium — this scheme will, I hope, toss up surprising juxtapositions and ask you, the viewer and reader, to look and think at every turn.

TO MAKE A PAINTING, subtraction is just as important as addition. Indeed, the two are indistinguishable. As a loaded brush moves over the canvas, it simultaneously pushes a quantity of paint ahead of itself and lets the rest slip under it, leaving the traces of its bristles behind in what we call a brushstroke. The stiffness and angle of the brush, the length and type of bristle, the pressure of the hand, the consistency of the paint, the texture of the canvas — all these help determine both how much paint will be left behind and how clear a trace the brush will leave in its wake. Thus, every brushstroke combines removal and deposit in a ratio that fluctuates over the course of the stroke. Likewise, when a palette knife is used instead of a brush, the ratio of removal to deposit depends on the length, width, and stiffness of blade, the angle and pressure of attack, and so on. As the ratio increases, we become aware of the removal and speak of scraping.

Modern art did not invent scraping or any other technique of the brush or knife. What is modern is the repurposing of scraping from an instrument of repentance to a positive means of creating particular appearances. This kind of shift is often ascribed to a desire to reveal the medium and its methods, abjuring the licked surface of nineteenth-century academic painting in favor of new, modernist slogans like "truth to materials" and "lay bare the device."[6] A scrape proved the artist had nothing to hide. But as soon as scraping became self-conscious, its honesty withered and it was just another way to manipulate paint. When Henri Matisse, a master of scraping, used the "wrong" end of the brush to scratch through paint to white ground in *Palm Leaf, Tangier* (see figure), the resulting marks, however radical they might seem, are careful and deliberate — as deliberate as the scratches that Jean-Honoré Fragonard used to

Henri Matisse, *Palm Leaf, Tangier*, 1912, oil on canvas, 46 ¼ × 32 ¼ in. (117.5 × 81.9 cm). National Gallery of Art, Chester Dale Fund

Henri Matisse, *Palm Leaf, Tangier* (detail)

describe the top of the armchair and the ruffled collar in *A Young Girl Reading* (c. 1776), another showpiece of *alla prima* painting at the National Gallery of Art.

The works in this section present a compendium of scraping techniques and purposes. Clyfford Still (cat. 6) and Josef Albers (cat. 11) used the palette knife to apply paint, but to opposite effect. Still troweled and dragged the paint over the canvas, building a dense, dry wall of "frayed-leaf and spread-hide contours," as Greenberg put it, with a flat materiality that is claustrophobic.[7] Albers, by contrast, used the knife to open the surface, bearing down evenly (taking advantage of the resistance of Masonite) until the white ground shone through, or flicking the knife to create reflective ripples. In *Untitled VI* (cat. 5), de Kooning used the knife as an alternate brush, swifter and smearier, producing a hard, marbled effect in contrast to the stately flow of his strokes. (This is a "misuse" of the knife, the prescribed purpose of which is to mix colors thoroughly on the palette.) Hofmann's *Autumn Gold* (cat. 3) attests to the many possibilities of the knife in a single canvas: troweling to create a thick layer, flourishing to create marbleized passages, scraping to reveal underlayers or ground.

In *Untitled* (cat. 7), a virtual essay on scraping, Julian Lethbridge combined two methods, first laying down a thick white layer with the broad edge of the knife, and then, after painting a network of black lines over that ground, dragging the tip of the knife (or something similar) along those lines, splitting each down the middle. Equally complex, in *Cote course mouche* (cat. 4) Jean Dubuffet used scraping to incise the figures into the surrounding ground, which stands proud of them. (In other works, using a method taught to schoolchildren, he scraped through black paint to reveal colors below.) In *Picasso's Skull* (cat. 8), Marden seems to have used scraping more traditionally, as a way to undo whole campaigns of painting, but in fact it

was his way to mute strong colors and gestures by embedding them within the fabric of the canvas (and within the slow time of his Penelope-like process). The color-surface resulting from all the painting and unpainting is hard, eroded, and weathered.

In Johns' work, the careful violence of modern scraping gets sublimated into a theme (cats. 9–10). Having already used a hinged board to smear circles and semicircles onto paintings, starting with *Device Circle* (1959; private collection), Johns represented that activity graphically in the two prints here, linking images of board and hand to recall the connection of that simple machine to his body. This is a double reference to Pollock, who used a board to imprint the eight angled vertical lines that organize *Blue Poles* (1952; National Gallery of Australia) and who often left handprints on many of his paintings, including the National Gallery of Art's *Lavender Mist* (1950). Pollock's method in his classic poured paintings was entirely additive and forward looking: if he overworked one, he would simply discard it. His commitment to spontaneous flow is one of the things that Johns' device, in joining hand and board, scrapes away.

THERE IS NO more powerful location, perceptually or symbolically, than a center, and no clearer way to mark it than by concentricity. In *First Disk* (1913; private collection), Robert Delaunay created a shockingly efficient image of concentricity, a tondo of quartered circular stripes. The following year, in *Political Drama* (see figure), he embedded a similar image in current events by using it as a backdrop to render the assassination of an editor of the French newspaper *Le Figaro*, underscoring the inherent politics of center and periphery. This work equates the focusing structure of concentricity with the targeting of a victim through the sights of a gun, but at the same time it instigates a countermovement, using color and other cues to suggest radiation out toward the viewer. The result is to create a distinct ambivalence of in and out.[8]

This simultaneity of centrifugal and centripetal movement, whether in depth or across a surface, is the abiding fascination of concentricity. Marcel Duchamp brought this out in his hypnotic spinning disks of the 1920s known as *Precision Optics*; so did Albers in his long-running series Homage to the Square, which he began in about 1950 (cat. 13). In both cases, the fact that the nested forms do not quite share the same center sets them slightly loose, encouraging the spatial dynamism of concentricity. For Albers, this dynamism came to stand for an issue at the very center of his work: the inescapable, often counterfactual impact of colors and shapes on the eye and brain of the viewer. "Art is not to be looked at / Art is looking at us," he wrote. [9]

Noland, who studied briefly with Albers at Black Mountain College in the late 1940s, achieved a similar in-out pulsation while adhering to strict concentricity. In *Mandarin* (cat. 12), the syncopated placement of rings, combined with close color variation, suggests the action of sound waves in a room or ripples on a pond, at once moving out to the limits of their container and bouncing back to the central, original disturbance. Stella, who was well aware of Noland's Circles (both in their compositional structure and in their acrylic-on-raw-canvas technique), kept the concentric squares of his *Gray Scramble* (cat. 16) marching evenly while achieving a similar in-out pulse through irregular color choice and placement.

It is remarkable that Delaunay's *First Disk* had (like a Freudian trauma) such a delayed effect: its concentricity was not fully seized by other artists until after mid-century. Part of the reason, surely, is that this work is all center, so to speak: it emblazons a principle of composition (centrality) whose power had always relied on being felt rather than seen. Even more taboo, the work is all edge: by deducing the composition inward from the round shape of the whole, it both shrinks aesthetic choice and squeezes out spatial illusion.[10] In the postwar period, a new wave of artists—Johns, Rauschenberg, Kelly, Stella, Donald Judd, Dan Flavin, and others—took up the search for ways to escape the subjective business of composition. Decisions about what to put where, which de Kooning and Newman had elevated to a heroic, risk-everything level, Stella brushed aside as "relational" painting.[11] But that was easier said than done. Johns, for example, made his Target paintings on rectangular canvases, not daring to imitate the collapse of figure and field in Delaunay's *First Disk*.

The full exploitation of the nonrectangular figure/field was left to Stella in shaped canvases like *Marquis de Portago* (first version) (cat. 20). The center is not a point but rather a line (the only straight one in the work) stretched between

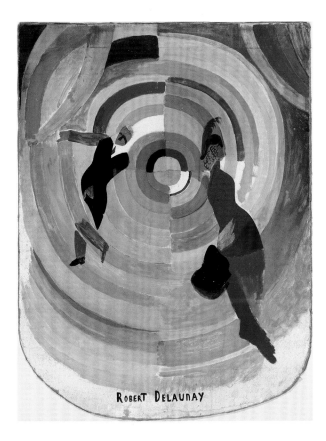

Robert Delaunay, *Political Drama*,
1914, oil and collage on cardboard,
34 15⁄16 × 26 ½ in. (88.7 × 67.3 cm).
National Gallery of Art, Gift of the
Joseph H. Hazen Foundation, Inc.

two notches in the canvas. From this radical cut, the rest of the composition follows in evenly paced stripes until the artist simply decided to stop.[12] The four resulting notches are, in effect, the center(s) of the composition. Stella's logically elegant structure draws out the lesson of Delaunay's *First Disk*: when you make a structure that is all center, the center becomes the edge.

Kelly performs an equally radical displacement of the center. All the curved edges of his paintings are segments of circles, the centers of which lie outside the canvas. This is nowhere truer than in *Red Curve* (cat. 17), in which the arc is part of an immense circle.[13] Jane Meyerhoff's low hanging of the work at their home, which Kelly approved, buries the center deep underground. Kelly once made an arc by using a tethered string so long that it extended far out the door of his studio to the next room.[14] By thus banishing the center from his shapes, Kelly, as if answering Arnheim, calls attention to the power of the edge.

And yet the center retains its visual and symbolic force. In Rauschenberg's *Autobiography* (cat. 19), the artist places himself within three concentric structures: his astrological chart, which overlays an X-ray of his own body (left); the parachute he wore in the 1963 dance performance *Pelican*, which overlays a nautical map of part of the Gulf of Mexico near his hometown (right); and his autobiography, written as an oval that spirals out from a family photograph, suggesting the whorl of a thumbprint writ large (center). The work is a three-ring circus, a riot of concentricity. In *Mirror's Edge 2* (cat. 15), Johns offers an image sandwich. The clearest layers are (near the bottom) the floor plan of his grandfather's house and (on the top) a spiral galaxy. In these two diagrammatic works, the center returns as the personal, the periphery as the cosmic — or is it the other way around?

"A LINE ON ITS own has almost become a work of art," declared Theo van Doesburg in 1915, reviewing Piet Mondrian's *Composition 10 in Black and White (Pier and Ocean)* (1915; Kröller-Müller Museum, Otterlo), a new work composed entirely of short black horizontal and vertical lines on a white ground.[15] The history of modern art might be written from here on as the story of line coming into its own. In the interwar period, one could contrast the use of line by the geometric-abstract artist to focus painting on its alleged essence, the ruling of a rectangular surface, with that of the surrealist, for whom line was a psychic seismograph, a tool to record alleged unconscious images and impulses.

History is not so neat. Joan Miró's *Head of a Catalan Peasant* (see figure), an icon of surrealism painted a year after the first manifesto of the movement, is made almost entirely of lines, but there is nothing unconscious or impulsive about them. Rather, Miró unleashed his impulses on another part of the painting: its ground, which he smeared, scrubbed, and punctured. But Miró's stick figure does demonstrate another impulse, that of stretching. The figure seems intent, down to its fingertips, on reaching the edges of the canvas. If we take Miró's Catalan peasant as a stand-in for its Catalan author, we can already glimpse the postwar impulse to match the scale of painting to the body of the painter.[16] De Kooning said, "If I stretch my arms next to the rest of myself and wonder where my fingers are — that is all the space I need as a painter."[17]

What does line have to do with the newly stretched scale of postwar painting? The answer is simple: Jackson Pollock. His line, wrote Fried in 1965, "loops and snarls time and again upon itself" until it is "freed at last from the job of describing contours and bounding shapes."[18] Pollock's

Joan Miró, *Head of a Catalan Peasant*, 1924, oil on canvas, 57 ½ × 44 ¹⁵⁄₁₆ in. (146 × 114.2 cm). National Gallery of Art, Gift of the Collectors Committee

achievement of a fully abstract, nonenclosing line relied on the athletic capacity of his pouring technique to set new records for line length and duration. When Rauschenberg and John Cage inked up the tire of an old car in 1953 and drove it over linked sheets of paper for 22 feet, they were, in a sense, simply straightening one of Pollock's lines while obeying his dictum about staying "in my painting."[19] Later in that decade, Piero Manzoni drew a 4.5-mile line and placed it in a sealed container. In the 1960s, conceptual artist Douglas Huebler proposed an artwork consisting of the contrail left by a jet flying across Canada.[20] In these works, increasingly absurd length makes line into a phenomenon, or a phenom — really something.

A self-conscious fascination with line length marks several works in this section. Marden's *Long Drawing* (cat. 31) is an outright homage to Pollock's longer, friezelike paintings, which tend to be stately and rhythmic; Kelly's 1999 drawing of a beanstalk reaches skyward, recalling the tale of Jack (cat. 23); Noland's 1968 stripe painting evokes (with the help of an apt title, *Via Breeze II*) the open road (cat. 30). Here, length is both material fact and declared theme. Drawing is understood literally as the act of extending or pulling, and composition becomes a test of endurance, a matter of ductile strength. In Rauschenberg's *Frigate (Jammer)* (cat. 22), two long lines, one of wood and another of wire, support a glass of water and a red flag, reminding us that, for all its minimalism, line is powerful, a handy thing to have on a foundering ship or a desert island.

In all these works, line becomes a thing in itself, an emphatic presence; flip the coin and it is nothing, near absence. In Agnes Martin's *Field #2* (cat. 29), an army of graphite lines moves across the canvas, delicately registering its bumpy surface. A single line would have stood out; together, the lines become tone. In Stella's *Flin Flon IV* (cat. 34), a fugue of radially symmetric shapes, overlapping and intersecting, is generated by nearly absent lines. (Within the curved strips of reserved canvas, one can detect the pencil lines that Stella used to lay out the composition.) Likewise, in Mel Bochner's drawing *First Fulcrum* (cat. 33), a study in merged and displaced pentagons, present-absent line is the generator of complex geometries and the fulcrum of its own disappearing act.

If Pollock's example did not put an end to traditional drawing, it certainly changed it. Dubuffet's *La ronde des images* (cat. 24) returns Pollock's endless tangles from abstraction to the figure, showing the capacity of line to suggest mass. Roberto Matta, combining the cosmic suggestions and semiautomatist procedures of Pollock's work, doodled a space colony in *Untitled* (cat. 26). De Kooning's *Two Women* (cat. 27), for all its elegant chiaroscuro, would not have been possible without the example of Pollock's slashing gestures.

Finally, a line about sculpture: Lichtenstein's *Sleeping Muse* (cat. 36) turns a famous work by Constantin Brancusi into a see-through logo. By collapsing the two poles of modern sculpture, the carving of stone or wood (Brancusi, Henry Moore) and the welding of metal (Picasso, David Smith), Lichtenstein proves that line can do anything.

Gesture

NO WORD HAS DONE more damage to the understanding of postwar painting. *Gestural abstraction* and *gesture painting* suggest sudden, spontaneous movements of the sort rarely made by the painters to whom the terms are applied. But if we take a close look at the word, it is not so inappropriate after all. *Gesture* is from the Latin *gestus*, which variously denotes bearing or comportment, a mode of action, or a dramatic performance. Thus, it embraces theater, sign language, and other kinds of self-conscious, physical communication. Harold Rosenberg underscored these connotations in 1952 when he proposed the term *action painting* as an alternative to *abstract expressionism*: "At a certain moment the canvas began to appear to one American painter after another as an arena in which to act," he wrote in the essay's most famous line. It is often forgotten that Rosenberg meant *act* as much in the dramaturgical sense as in the physical. "What gives the canvas its meaning is not psychological data but *rôle*," he continued. "Since the painter has become an actor, the spectator has to think in a vocabulary of action … must become a connoisseur of the gradations between the automatic, the spontaneous, the evoked."[21]

The artist most often cited as the father of mid-century gestural abstraction is Wassily Kandinsky: "His free handling of colour and line in the years just before the First World War … may be seen today as the basis of contemporary gesture or action painting."[22] But just how free? In Kandinsky's *Improvisation 31 (Sea Battle)* of 1913 (see figure), strong black lines and scrubbed patches of color course across the canvas, but their movement is constrained by a monumental triangular composition. Kandinsky's title reflects this dialectic of freedom and control: "improvisation" suggests spontaneous expression while "sea battle" evokes that most slow-moving of military engagements and a highly orchestrated set piece of many marine paintings.

The Meyerhoff collection includes two great examples of postwar gestural abstraction, de Kooning's *Spike's Folly II* (cat. 38) and Kline's *Turbin* (cat. 39). Taken together, they have much to tell us about the stage management of gestural fireworks at mid-century. Just as Kandinsky's painting features a battle between two ships (defined by long vertical masts), so the paintings by Kline and de Kooning are built on an agon of opposing forces: black and white in the former, light (white, beige, yellow) and dark (black, blue) in the latter. And just as Kandinsky carefully composes, Kline and de Kooning hang their dramas on a vertical-horizontal armature echoing the shape of the canvas. De Kooning hews more closely to the armature, which makes the few diagonal exceptions, like the dramatic spray of white paint that explodes across the blue rectangle, so effective. In Kline's painting, persistent diagonals threaten the structure, creating a tension that does not get released in a single climax but rather sheds energy throughout, as black lines shiver and splinter at their edges. In both works, light-dark contrasts carve an illusion of space out of the surface even as frank brushstrokes weave over and under one another, reminding us of it. Phallic elements and suggestions of combat evince a masculine visual rhetoric that has become more obvious with passing time.

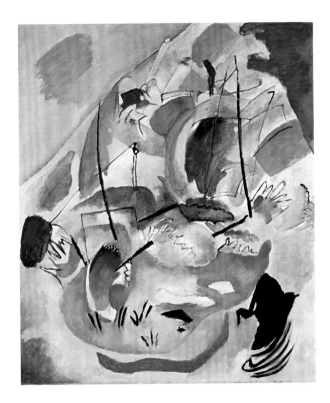

Wassily Kandinsky, *Improvisation 31 (Sea Battle)*, 1913, oil on canvas, 55 ⅜ × 47 ⅛ in. (140.7 × 119.7 cm). National Gallery of Art, Ailsa Mellon Bruce Fund

After this historical high-water mark, gesture ramified into several modes. In the nonpainterly mode, powerful, visceral movements are suggested more by shape than by handling. The essential gesture of Kelly's *Blue Violet Curve I* (cat. 44) is a cantilever achieved by the dramatic vertical anchoring of a long arc. One might also speak of a hyperpainterly mode. In de Kooning's *Untitled* (cat. 42), a plethora of brushstrokes, made with more wrist than elbow, increases overall energy but reduces drama. And then (recalling the relation of *gestus* to sign and semaphore) there is a syntactic mode, in which discrete gestures are linked together much as words join to form sentences. Caro's *Table Piece LXX* (cat. 40) and Hartigan's *Essex and Hester (Red)* (cat. 41) are all about the connection of diverse but related gestures.[23] In Stella's Playskool series of wall-mounted reliefs (cats. 46–53), gesture is conveyed both via the playful, physical connection of elements (by clamp, peg, rod, bolt, latch, etc.) and by the unpredictable shapes of the elements themselves.

If Stella retrieves mid-century painterly gestures by recourse to another, less gestured-out medium than painting, Lichtenstein embalms them. His sculpture *Brush-strokes in Flight* (cat. 37) punctures the afflatus of gestural abstraction by literalizing it. *Painting with Statue of Liberty* (cat. 43), a sort of diptych divided by an ornate old-world frame, reminds us that abstract expressionism, that heroic American style, had its origins in Europe.

ART HAS ALWAYS been about, around, and for other art, a matter of renascence and regurgitation. As Leo Steinberg put it, in 1978, "Whatever else art is good for, its chief effectiveness lies in propagating more art. Or: Of all the things art has an impact on, art is the most susceptible and responsive." But while artists for centuries sought to hide their sources, modernity brought what Steinberg calls a "catastrophic unmasking," epitomized by the way Edouard Manet lifted three figures from Marcantonio Raimondi's engraving after Raphael's lost *Judgment of Paris* and plopped them, without the usual inversions or rearrangement (but with the scandal of modern dress and undress) into his *Déjeuner sur l'herbe* (1863; Musée d'Orsay, Paris).[24]

After Manet, citation and quotation become ever more explicit. Artists often lift and insert other art into their work rather than just use it as a model. Matisse's *Pianist and Checker Players* is a (somewhat traditional) case in point (see figure). The insertions include a cast of Michelangelo's *Dying Slave*, several paintings by Matisse himself, and — expanding our definition of art — an Oriental carpet, some arresting clothing, Matisse's two violins, a piano, and furniture. Indeed, it is Matisse himself who expands the definition for us, integrating these objects into a leveling play of unremitting pattern. Decoration was not a pejorative word for Matisse: his painting proposes a domestic environment in which various types of artistry and play are integrated with life, becoming even more than its décor.

Given the social function that art played in the development of bourgeois culture, it is no accident that Matisse made this proposal in the living room, the locus of domestic sociability. But there are other artists and other rooms:

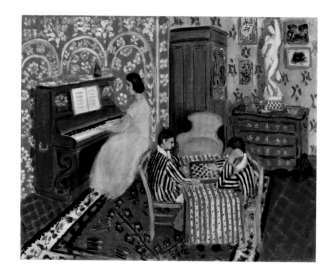

Henri Matisse, *Pianist and Checker Players*, 1924, oil on canvas, 29 × 36 ⅜ in. (73.7 × 92.4 cm). National Gallery of Art, Collection of Mr. and Mrs. Paul Mellon

1. The bedroom. In a 1992 painting (cat. 62), Lichtenstein reimagines Van Gogh's *Bedroom at Arles* as a mid-century modern interior complete with Breuer chairs and a Parsons table (perhaps a pun on Van Gogh's abortive choice of vocation). Two paintings on the wall are rendered in Ben-day Dots. As the original bohemian interior, lacking even a closet, gets updated but not really upscaled, the aura of a site sacred to Van Gogh lore is stripped, or at least displaced, onto the new, disturbing wood floor, which suggests ears, mouths, and other orifices.

2. The courtroom. In Philip Guston's 1970 painting of that title (cat. 63), first exhibited that year in a shocking show at Marlborough Gallery of his raw new figuration, the Mickey Mouse arm of justice points ineffectually at an unconcerned Klansman, while the clock on the wall suggests that it is already too late. He is spattered with blood or paint. Behind him a trash can is filled with bits of stretchers and a pair of legs. Among the blank paintings on the wall, a brick, inspired by George Herriman's cartoon Krazy Kat, floats in the air.

3. The bathroom. Tub faucets at lower right indicate the setting of Johns' *Racing Thoughts* (cat. 61). A pot by George Ohr and another one honoring the Jubilee of Queen Elizabeth, with her profile and that of Prince Philip in negative, share a table. The walls are decorated with reproductions: a 1961 lithograph by Newman owned by Johns (an example of which the Meyerhoffs acquired a year after buying this painting; cat. 59); a jigsaw-puzzle portrait of Leo Castelli, Johns' first dealer; a reproduction of the Mona Lisa, needlessly labeled as such; and a highway sign in German and French warning of ice. Hidden in the hatching at left are some contours of Matthias Grünewald's *Isenheim Altarpiece*.

All these rooms are really studios. Van Gogh painted in his bedroom. Guston's Klansman in court is an artist in his studio. Johns' bathroom, like his paintings, is a field of slipping, sliding images. Reproduction and self-reproduction are everywhere. Van Gogh painted three versions of his bedroom in Arles. Guston turned out his Klan paintings at a great rate, mixing and matching elements and images. Johns painted a colored version of *Racing Thoughts* the year before he painted this monochrome one (1983; Whitney Museum of American Art, New York). With the modern replacement of emulation by quotation and self-quotation, the artist advances and retreats, becoming a god who rearranges the world with impunity while disappearing into a tissue of reference.

We have entered a hall of mirrors with the missing artist at center. Johns' 1982 print *Savarin* is "a self-portrait masquerading as a still-life" (cat. 54).[25] The coffee can with brushes sits on a box containing a red armprint labeled with the initials of Edvard Munch, who used such self-printing in one of his own works. Given the reliquary-like associations of body parts, and Munch's fascination with death, the can becomes an urn. The artist paints with his own blood and ashes, and leaves his mark.

WHEN *TIME* MAGAZINE dubbed Pollock "Jack the Dripper," in 1956, it confirmed that his technique of pouring paint, with its resultant drips and skeins and spatters, was central to a whole era of art making. "You can't do a painting without a drip," Warhol declared to the dealer Ivan Karp five years later, when Karp, working for Castelli, first visited the studio and asked why some of the artist's cartoon-based figures were careful while others were splashy. "Well, I prefer to do them that [careful] way, but it seemed that there would be no audience interest in any work that was not expressive in this style."[26] If the anecdote demonstrates Warhol's purely instrumental attitude to style from the very beginning, it also foreshadows his Oxidation paintings of 1978, in which he created patterns on copper-painted canvases by urinating on them in homage to the story of Pollock peeing in the fireplace of his patron Peggy Guggenheim. Thus, with the help of Warhol and *Time* and Pollock himself, violence, class resentment, male sexuality, and expressivity were all woven into the myth of abstract expressionism.

This account of the meanings of the drip is highly selective. To begin with, it forgets that the drip predates Pollock. It was Arshile Gorky who quipped, "If Picasso drips, I drip."[27] In *One Year the Milkweed* (see figure), his drippiest work, Gorky (like Pollock) uses pouring to evoke an unconscious substratum in which nature and culture, accident and control, merge. But — and the distinction is crucial — Gorky drips down a vertical canvas while Pollock drips onto a horizontal one. Pollock's particular use of gravity was viewed as masculine, and indeed some of the resulting

forms, as in his *Untitled* (cat. 70), an ink drawing probably made with the help of a turkey baster, suggest ejaculatory spurts. In Gorky's painting, by contrast, paint thinned with turpentine runs down the canvas, creating a liquid veil that amplifies the feminine fecundity of the picture's egglike shapes and of its title.

Fearing to be seen as imitators, few artists followed Pollock in his method of pouring and dripping paint onto a horizontal canvas. (Interestingly, two women were prominent among those who did: Helen Frankenthaler and Lynda Benglis.) Pollock-like splashes and spatters were achieved, rather, by a slap of the loaded brush, as in de Kooning's *Spike's Folly II* (cat. 38). Abstract expressionist dripping had less to do with "Jack the Dripper"–like expressive masculinity than with Gorky's runniness.

Look again at Kline and de Kooning. In Kline's *Thorpe* (cat. 68), two long drips descend from the top of the black ideograph, and shorter, weaker drips come off the bottom. De Kooning's *Untitled* (cat. 69) is punctuated by random drips, some given off by the liquid-loaded brush before it touched down. There is bravura in these drips, a devil-may-care attitude toward process, but there is also a delicacy in their fragile, uncertain course and a haphazard lyricism in their spontaneous effusion of paint. If these drips are gestures, they are so in the sense that Roland Barthes gives to Twombly's graphisms: "a garble, almost a smudge, a negligence."[28]

After abstract expressionism, younger artists took up the drip with interest and originality, not simply — as often alleged — in parody. In *Bypass* (cat. 71), Rauschenberg deploys drips in discrete areas, like the blocks of text or paint he also uses, creating an impression of a sudden overflow or a sprung leak that adds to the effect of montage

Arshile Gorky, *One Year the Milkweed*,
1944, oil on canvas, 37 ¹⁄₁₆ × 46 ¹⁵⁄₁₆ in.
(94.2 × 119.3 cm). National Gallery
of Art, Ailsa Mellon Bruce Fund

and discrepancy throughout. Johns, by working with heated encaustic that dried as it cooled, was able to slow and thicken the drip, turning it into a kind of fossil or cast of itself. In *Perilous Night* (cat. 72), such drips, with their distinctively large terminal drops, are everywhere. The three cast arms at right bleed their respective primary colors; they seem engaged in patient wiping, which helps to set the distinctively slow tempo of the work. Multiplied and released, the drip is equated with diaphanous fabric in Hartigan's *Josephine* (cat. 73) and with a scrim in Johns' *Screen Piece 4* (cat. 74). Prominent drips in Marden's *Cold Mountain 5 (Open)* (cat. 76) add to the liquid translucency achieved by a layering of networks. Johns' *Untitled* (cat. 75) makes an explicit equation between dripping and shrouding. Such is the legacy of Gorky's drip as veil.

Johns rescued the drip from de Kooning and Kline by isolating it from its concomitant gestures and spatters. All three elements (drip, gesture, spatter) are brought back together, but as static image, in Lichtenstein's *White Brushstroke II* (cat. 78), which thus serves as a succinct summary and send-up of the allegedly virile grammar of abstract expressionism. From here it is a short step to the flaccidity of Claes Oldenburg's *Soft Drainpipe — Red (Hot) Version* (cat. 77), with its imagined dripping.

AS THE HISTORIAN Michel Pastoureau argues in *The Devil's Cloth*, stripes have been associated since the Middle Ages with marginality, transgression, pollution, and revolution, appearing more often on prison uniforms, underwear, barber poles, flags, and danger signs than in paintings.[29] This makes sense, given that pure striped patterns are optically disturbing, lacking even the modicum of balance conferred when stripes cross in the grid (a much more common device in "high" art). The most radical of modern artists — Matisse in his Nice period of the 1920s, Picasso in his portraits of Dora Maar of the 1930s and 1940s — were attracted to the stripe for these very reasons. One of the rawest essays on the subject is Ernst Ludwig Kirchner's *The Visit — Couple and Newcomer* (see figure), which hammers out a rhythm of red and yellow to describe the stairs and floor of a hot, square attic.

The shock value of stripes received its most matter-of-fact expression with Johns' first *Flag* (1954–1955; Museum of Modern Art, New York), which devoted an entire canvas to the collaged rendition, or presentation, of a flat American flag. It was the beginning of a long Johns romance with stripes: his *Untitled* (cat. 85) makes the connection, in retrospect, between his so-called Crosshatch paintings and his Flags. It was also the beginning of Stella's romance: having seen Johns' *Flag* at the artist's 1958 solo show at Castelli's gallery, he filled his paintings with stripes for years. In Stella's *Untitled* (cat. 80), a small gouache, the relationship of stripe and block recalls the structure of the American flag, with its forced marriage of stripes and canton. In larger paintings that year, stripes proliferate and overwhelm the block until it disappears altogether in his Black paintings of late 1958–1959.

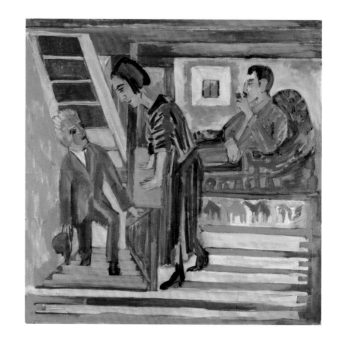

Ernst Ludwig Kirchner, *The Visit — Couple and Newcomer*, 1922, oil on canvas, 47 ½ × 47 ⅝ in. (120.6 × 120.9 cm). National Gallery of Art, Ruth and Jacob Kainen Collection, Gift (Partial and Promised) in Honor of the 50th Anniversary of the National Gallery of Art

Even without the coloristic stridency of Kirchner or Stella, there is something radically antiaesthetic about a field of stripes. The pale colors and strict repetition of Martin's *Untitled #2* (cat. 86) suggest printed fabric: she was confident that her handmade art would transcend such associations, which are inherent to the use of canvas. Rauschenberg, by contrast, welcomes them: in *Rose Condor (Scale)* (cat. 87), a piece of striped fabric turns the picture plane (with the help of a red pillow) into an upended bed. Lichtenstein's *Entablature* (cat. 88) makes visible the countless stripes that have framed everyday life for centuries in the guise of architectural moldings.

Recording the abstract patterns he found in beach cabana awnings and in the shadows that railings cast on stairways, Kelly had been quietly finding stripes across France as early as 1948. Unlike Stella, Kelly moved from stripe to block or, better, demonstrated the arbitrariness of that distinction. In *Blue Yellow Red V* (cat. 81), a vertical stack of the three primary colors, the blue area is clearly a stripe and the yellow a block, but the red is just wide enough to be undecidable. A similar ratio structures Rothko's *No. 3 (Bright Blue, Brown, Dark Blue on Wine)* (cat. 84). Here the bottom field is undecidable not just in shape but in color, where (as the title indicates) Rothko lets an underlayer shine through. Marden's *Grove Group III* (cat. 83) is also a kind of triptych, this time horizontal, which triggers religious connotations, but unlike an altarpiece size is held equal, allowing a neutral presentation of matte colors arrived at by painstaking mixing and layering. Undecidability is lodged in the identities of the colors, especially the one at left, which hovers between light and dark, blue and green. Once again, the tripartite format is exploited to take apart duality.

Enter the zip. "It is a small red painting, and I put a piece of tape in the middle … my so-called 'zip.' Actually it's not a stripe," said Newman in 1969 of his breakthrough painting, *Onement I* (1948; Museum of Modern Art, New York). Newman first used the term publicly in 1966, perhaps to distinguish his stripes from those of Stella, Louis, Gene Davis, and many others. One commentator suggests that the main reasons for Newman's neologism were, first, to steal a march on Pop art, with its *zips* and *blams*, and second, to underscore his aesthetic ideal of presence by finding a label that was both an onomatopoeia and a proper name (types of words in which sign and referent are tightly linked).[30] I would suggest another reason: a zip, or zipper, is an ingenious device for closure, and as Yve-Alain Bois has pointed out, it was the wholeness, singleness, and unity of the pictorial field that Newman sought to declare again and again.[31]

Newman's portfolio of lithographs *18 Cantos* (cat. 89) dramatizes the role of the zip in achieving this unity in and through the very act of division. As in *Onement I*, bilateral symmetry is key. In the *Cantos*, Newman begins with central zips in the first four prints, then dares some asymmetry, then returns to symmetry, first simply dividing the image into two equal halves and finally reintroducing the central zip as a wide band or block. By now this widening is familiar to us and perhaps betrays a desire to escape Pastoureau's "devil's cloth" after all. And yet Newman pursues the issue of stripes quietly, in the margins, in the variable *strips* that frame each *Canto*.

WE HAVE BEEN here before, whether in Pollock's line, which shrugs off the job of making shapes, or in Johns' flag, which virtually irons the image onto its support, or in Newman's zip, where "meaning lies entirely in its co-existence with the field to which it refers and which it measures and declares for the beholder."[32] Such cases betray the profound desire of modernism to escape the hierarchy of figure over ground, to make of painting a single texture that would have no space but its own, the space of a surface equally emphatic at every point, not fictional but real, hence abstract in the most radical sense. The words come easily from this late vantage point, and yet the desire remains, always utopian, never quite realized whatever the stratagem.

Piet Mondrian is a foundational figure in this particular tale. His *Tableau No. IV* (see figure) might appear at first to be the image of a grid glimpsed through a diamond-shaped window, hence set back in space, with the various colors in the grid advancing and receding, as colors do, with the whites falling away farthest, becoming empty space. Look again: Mondrian has varied the shades of white to avoid backgroundlike neutrality, and he has placed the corner of the brightest white shape at the very edge of the canvas, canceling the window effect and bringing this one "whole" shape up against our eyes. But why this dialectical to and fro between traditional illusion and declared surface? Why not simply cover the canvas with a single regular pattern or a flat monochrome field and be done with it? Because Mondrian refused to be done with the business of composition (he had tried and abandoned all-over checkerboards and other such patterns in the late teens) and

decided instead to drag all the basic resources of painting (line, shape, color, value) into his new pictorial reality. Thus the deliberate weave of surface and depth (note the different line thicknesses, playing their own game of to and fro, in fugue with that of the colors), which reaches its apogee in his late Boogie Woogie paintings.[33]

The strategy of a weave, at once material and optical, has proven inexhaustible as painters keep struggling to defeat figure and ground without defeating painting as well. In Reinhardt's pair of untitled paintings from 1950 (cats. 99–100), an elaborate interlace of two colors makes it difficult to decide which one encloses the other and hence presents the other as foreground. (The yellow and white painting is more ambitious and less successful: Reinhardt fails to get the white to come forward even though he is careful to keep it away from the edge, where it would fall away.) These works anticipate the classic solution he arrived at in his darker works, like *Abstract Painting* (cat. 94), in which color and value contrast is so minimal, and saturation so intense, that definable spatial relations yield to mirage. Rauschenberg's *Black Painting* (cat. 93) independently pursues a similar course, but in the register of dense materiality rather than evanescent opticality. One of the pictorial resources he seeks to preserve here is the sense of a frame and hence of a center: note how the collage elements do not extend all the way to the edge. In *Ritual* (cat. 101), another painting from the same moment, Pollock reaches back in time before his classic, poured works, attempting to bring human figures into all-over abstraction by recourse to his early, mythic/Jungian material. The effort succeeds, to the extent it does, because of the parallel slashing diagonals that score and oddly reorganize the surface, prohibiting our reading it in depth.

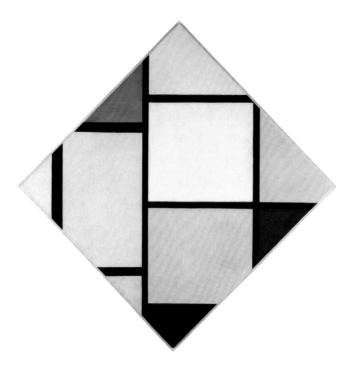

Piet Mondrian, *Tableau No. IV; Lozenge Composition with Red, Gray, Blue, Yellow, and Black*, c. 1924/1925, oil on canvas, 56 ¼ × 56 in. (142.8 × 142.3 cm). **National Gallery of Art, Gift of Herbert and Nannette Rothschild**

In the later works in this section, weaving becomes an explicit theme as well as a device. In *Compagnie fallacieuse* (cat. 91), Dubuffet offers a game of hide-and-seek that is difficult to win until we realize that the prominent black rivulets are not figures but the spaces between them. In two Crosshatch works (cats. 95–96), Johns' totalizing weave eliminates the ground and focuses us (or perhaps distracts us) instead with the problem of identifying the five panels and the logic of their reflections and inversions. In *Graphics Tablet* (cat. 92), a painting that has more to do with the spatial suggestion of Mondrian's Pier and Ocean works than with the utter flatness of Dubuffet's painting (despite the resemblance), Terry Winters risks the suggestion of a vast spherical space by weaving it into a coffered pattern that scans the surface. Finally, in *6 Red Rock 1* (cat. 90), Marden takes up the hide-and-seek game again. The fact that the red, dark blue, and green lines enclose shapes is all but lost in the complex network. (The only lines that do not join to make forms are the yellow ones, which constitute the deepest layer in this nonweave that only seems to be a weave.) The linear elements float above an orange field, but the fact that each color of line does some duty along the edge helps anchor them to the ground.

Many of these examples combine the weave with the grid, which is an equally famous means in the battle to map figure onto ground. In *Souvenirs* (cat. 98), Hodgkin uses a grid of splotches to declare the painted surface even as we glimpse smaller incidents through it. Such a double scale is a classic device of illusionistic painting, one that Lichtenstein literally takes apart in *Painting with Detail* (cat. 97).

1a. A picture, especially a painting, done in different shades of a single color.... 2. The state of being in a single color. 3. A black-and-white image, as in photography or on television.[34]

THE MONOCHROME IN these first two senses has been a staple of modernism, a basic term in its search for reduction and essence, from Picasso's Blue Period to Aleksandr Rodchenko's *Pure Red Color*, *Pure Blue Color*, and *Pure Yellow Color* (1921; private collection) to works here by Still, Albers, Kelly, Noland, Reinhardt, and Newman. Monochrome in the third, more restricted sense, an image in black and white, a no-chrome, has been equally important, starting with analytic cubism. In *Nude Woman* (see figure), color is restricted to shades of brown, black, and gray. This bracketing out of color, often attributed to Picasso's desire to focus on matters of form and space, can also be seen as a reference, on the one hand, to the tonality of old master paintings, especially ones in which the varnish has darkened and yellowed, as well as to the traditional use of grisaille both for underpainting and as an end in itself, and, on the other hand, to photography (as the third definition above suggests), which was rarely colored at the time of cubism, and to the newspaper, which was a kind of talisman object for cubism.

It is no accident that when Picasso turned back to the no-chrome in *Guernica* (1937; Museo Reina Sofia, Madrid), it was to deal with the horrors of current news. The success of *Guernica* has often been debated but not its tremendous impact, in both scale and ambitious address of a tragic subject. The dramatic black-and-white mid-century paintings of de Kooning, Kline, Pollock, and Robert Motherwell, with their resounding clashes, would have been unthinkable without this precedent. And yet these

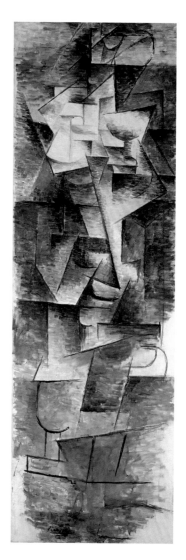

Pablo Picasso, *Nude Woman*, 1910, oil on canvas, 73 ¾ × 24 in. (187.3 × 61 cm). National Gallery of Art, Ailsa Mellon Bruce Fund

paintings are not monochrome if we consider black and white as colors; they are bichrome. The idea of painting in just white or just black remained on the margins at mid-century: all-black paintings by Rauschenberg (e.g., cat. 93), who also made all-white paintings, and by Reinhardt were a pointed response to the dramas just mentioned. But, as Kandinsky reminds us, black and white alone have their own claims to profundity and extremity: "White is not without reason taken to symbolise joy and spotless purity, and black grief and death. A blend of black and white produces grey, which...is silent and motionless.... The immobility of grey is desolate."[35]

As demonstrated in the 2007–2008 exhibition *Jasper Johns: Gray*, it was Johns, drawing perhaps on precedents in Mondrian, Juan Gris, Giorgio Morandi, Philip Guston, and Alberto Giacometti, who made the color gray his own in 1956 and proceeded to apply it to all his motifs.[36] In *Night Driver* (cat. 103), gray is pushed to the edge of black, obscuring colors glimpsed on and around collage elements at bottom. In *Two Maps* (cat. 106), gray is pushed to the edge of white, and again color is actively canceled, given that maps (like targets and flags, for that matter) are normally highly colored. Marden, an early admirer of Johns, explored the graying of colors both in wax paintings (as in *Grove Group III*; cat. 83) and in dense charcoal drawings like *Untitled* (cat. 104). At roughly the same moment as this drawing, Rothko turned to black and gray. Although it appears to be just black in reproduction, *No. 2* (cat. 107) is actually a study in gray and silver, given the way that the central field reflects light.

Rauschenberg, Johns' close collaborator in the latter half of the 1950s, took another path to gray. His technique of transfer drawing, which involved treating newspapers and other printed materials with solvent and then rubbing them to transmit a reversed image onto paper or canvas, was a new way (the first since cubist collage) to bring the news-

paper directly into the work. That this involved the graying of Rauschenberg's sources is reflected in the words of *Decoder III* (cat. 102): "Do not color this." A later transfer work, *Treat (Syn-Tex Series)* (cat. 109), plays with the same issue by including multiple advertising images in black and white of a television set with the word *color* on its screen. For both Johns and Rauschenberg, their persistent graying of the world carves a separate sphere for art, not desolate (recalling Kandinsky) so much as silent.

Black, white, and gray have long been part of Kelly's exploration of the monochrome. *Dark Gray and White Panels* (cat. 108) might seem to reinstate the heroic contrasts of abstract expressionism, but its segregation of the two colors into physically and geometrically distinct stretched canvases ensures that their mutual contact will be oblique. The white shape, with its two right angles, suggests part of a rectangle that has been interrupted or, better, overlaid by the more aggressive, fully irregular quadrilateral of dark gray. Their relationship is one of mutual sliding, not clashing.

"**DECONSTRUCTION MUST** neither reframe nor dream of the pure and simple absence of the frame," wrote Jacques Derrida in *Truth in Painting* (1978). "These two apparently contradictory gestures are the very ones — and they are systematically indissociable — of *what* is here deconstructed."[37] In this offhand way, the French philosopher identifies two principal modernist operations aimed at the frame: its multiplication, on the one hand, and on the other its reduction to a mere wooden strip, then nothing. René Magritte's *La condition humaine* (see figure) demonstrates both: there is a painting within the painting (multiplication), and it has several pseudo-frames — the window, curtains, moldings — but it has no real frame (elimination).

Why this double move against the frame? What galled modernists about it? It was not just that the traditional overlapping frame acted as a proscenium or window that supported the fiction of a deep pictorial space, which modernism rejected; the frame also helped contain the picture, shoring it up by complementing its internal relations and dividing it securely from the less organized world outside. The dream of modernist painting, which Derrida traces back to Immanuel Kant's aesthetics, was an autonomous, self-evident, almost self-generating picture that had no need of external support to secure its coherence and status.

For Greenberg, the way to achieve autonomy as well as flatness was by introjecting the absent frame, that is, by reflecting and obeying the conventional rectangularity of the edge in every part of the composition.[38] In this respect, the stacked rectangles of Rothko's *Untitled (Mauve and Orange)* (cat. 110) are orthodox, the trued and faired elements of Burgoyne Diller's *First Theme* (cat. 113) even more so. Still farther along the scale we find Albers' Homages to the Square and, finally, Stella's striped paintings, which are all frame (see *Gray Scramble,* cat. 16). Here, as

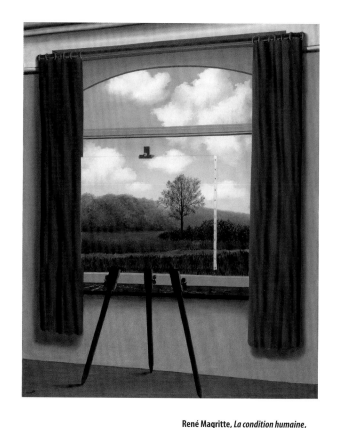

René Magritte, *La condition humaine*, 1933, oil on canvas, 39 ⅜ × 31 ⅞ in. (100 × 81 cm). National Gallery of Art, Gift of the Collectors Committee

in Magritte's painting, the presence of internal edges echoing the shape of the whole takes pressure off the outer edge, which becomes just one among others. We might even forget that the image has a definitive limit. Thus, the extreme multiplication of the frame/edge goes hand in hand with its (fantasized) elimination.

With Rauschenberg's early work, this strategy weakens from within. In *Tour* (cat. 126), *Brace* (cat. 111), and *Archive* (cat. 115), internal multiplication (gridded rather than concentric) is rampant: each image gets its own rectangular compartment, but the edges are now blurred, their alignment uncertain. The action of individual incidents begins to trump the coherence of the whole. As the logic of the newspaper, with its grid of convenience, takes over, the modernist dream of an autonomous picture recedes.[39] The frame or edge becomes an object of derision. Between Johns' *Untitled (A Dream)* (cat. 119) and *Untitled (M.T. Portrait)* (cat. 120), the contents of the outer and inner picture change places; only the inner support, a page "nailed" to the canvas, stays in place, along with a similarly nailed watch. In *Bread* (cat. 117), Johns sends up the strategy of concentricity by proposing a slice of processed bread as a frame within the frame. In Joel Shapiro's untitled drawing (cat. 112), oblong rectangles that echo the shape of the whole sheet struggle to maintain their integrity and stability in a storm-field of marks.

The whole apparatus of framing receives more mockery from Lichtenstein. In *Fragmented Painting of Lemons and a Melon on a Table* (cat. 125), a corner of the depiction has been lifted to reveal a stretcher, with its keys, beneath. (Johns had made much the same revelation in the early 1960s, except with real stretchers, a history that Lichtenstein enjoys depicting here.) In *Reflections: Nurse* (cat. 121), a curved frame, mat, and glass are made part of the depiction; in *Old Money* (cat. 122), Hodgkin makes the frame part of the picture in another, more venerable way, painting over it à la Georges Seurat.

All these acts of derision and incorporation can still be understood, with Derrida, as part of the long modernist love-hate relationship with the frame. There is no getting around the frame's vicious logic, for as long as one is making objects called paintings, there will be the question of distinguishing them from their surroundings, and since any frame or even edge (as in the tacking edge revealed in Magritte's painting) has a thickness, its own inside and outside, the question doubles and the game continues. One apparent way around it, as with Kelly's *Chatham III: Black Blue* (cat. 114), is to make paintings whose shapes are so unusual that they are not insistent on their own wholeness but rather make the most of their inevitable condition of existence on a wall, making a composition with that architecture. But even so, there is the question of just where the painting ends. Like any painting, Kelly's casts a shadow, and we felt impelled, in Kelly's case, to include it in the photograph reproduced here. Call it the shadow of modernism.

1. B. H. Friedman, *Jackson Pollock: Energy Made Visible* (New York, 1995), 253.

2. At a public discussion with the Meyerhoffs in the National Gallery of Art on the occasion of the 1996 exhibition of the collection, art dealer Irving Blum suggested to Jane Meyerhoff that the two of them write down the name of the one artist whose absence from the collection was most glaring. They both wrote "Twombly."

3. After writing this essay, I was surprised to discover that Jane Meyerhoff, in her preface to the National Gallery of Art's 1996 catalogue of the collection, referred to Paul Klee's "thinking eye" (the title of his 1956 book) to convey how she and her husband approached the task of collecting by supplementing looking with reading and study. I must have read that preface, given that that catalogue was the occasion of my own first publication in art history (entries on Josef Albers and Burgoyne Diller). Mark Rosenthal et al., *The Robert and Jane Meyerhoff Collection: 1945 to 1995* (National Gallery of Art, Washington, 1996), 11.

4. See John Elderfield's discussion of these quotations in "Picasso's Extreme Cézanne," in *Cézanne and Beyond* (Philadelphia Museum of Art, 2009), 213–214.

5. Rudolf Arnheim, *Visual Thinking* (Berkeley, 1969).

6. The former phrase, used by Henry Moore to describe his belief that different materials dictated different kinds of sculptural form and handling, is also common in the discourse of modernist architecture; the latter phrase was invented by the Russian formalist literary critic Viktor Shklovsky.

7. Clement Greenberg, "'American-Type' Painting" (1955/58), in *Art and Culture: Critical Essays* (Boston, 1961), 224.

8. "In and out, gunshot and light, the lines of sight in *Political Drama* shoot into the space of the painting while simultaneously pushing back, projecting toward the viewer." Gordon Hughes, "Envisioning Abstraction: The Simultaneity of Robert Delaunay's *First Disk*," *Art Bulletin* 89:2 (June 2007): 324.

9. This is the opening line of his poem "Seeing Art," which is reprinted in *Josef Albers* (North Carolina Museum of Art, Raleigh, 1962), 11.

10. Michael Fried analyzed what he called the "deductive structure" of Stella's striped paintings in his *Three American Painters: Kenneth Noland, Jules Olitski, Frank Stella* (Fogg Art Museum, Cambridge, MA, 1965), 40–48. In doing so, he drew on Greenberg's discussion of Newman's thin paintings in "'American-Type' Painting": "With Newman, the picture edge is repeated inside, and *makes* the picture, instead of merely being *echoed*." Greenberg 1961, 226.

11. Bruce Glaser, "Questions to Stella and Judd," in Gregory Battcock, *Minimal Art: A Critical Anthology* (New York, 1968), 148–164.

12. Had he kept going, the result would have been a square painting with four equal notches; as it is, the ratio of side notch to center notch mirrors the height-width ratio of the canvas.

13. The two equal rays that support the arc do meet in a center in terms of left-right placement, but that center only serves to remind us how far we are from the center of the work's implied circle.

14. As reported to the author by Yve-Alain Bois, recalling a visit to Kelly's studio.

15. Van Doesburg reviewing a group exhibition in Amsterdam in 1915, cited in Yve-Alain Bois et al., *Piet Mondrian: 1872–1944* (National Gallery of Art, Washington, 1994), 170.

16. Charles Palermo, *Fixed Ecstasy: Joan Miró in the 1920s* (University Park, PA, 2008), 100, 125, 133–134.

17. In the two preceding sentences, de Kooning equates an arm's width of canvas to a starry sky, reinforcing the parallel with Miró's painting: "The stars I think about, if I could fly, I could reach in a few old-fashioned days. But physicists' stars I use as buttons buttoning up curtains of emptiness." De Kooning, "What Abstract Art Means to Me" (1951), in Thomas B. Hess, *Willem de Kooning* (The Museum of Modern Art, New York, 1968), 146.

18. Fried 1965, 13–14.

19. Jackson Pollock, statement in *Possibilities* (Winter 1947): 79.

20. Two more examples: In *Mile Long Drawing,* Walter de Maria drew two mile-long chalk lines in the desert. In *Time Line,* Dennis Oppenheim traced the U.S.-Canada border by walking in the snow along the middle of the frozen Saint Lawrence River. See Nancy Foote, "Drawing the Line," *Artforum* 14:9 (May 1967): 54–57.

21. Harold Rosenberg, "The American Action Painters," in *The Tradition of the New* (New York, 1961), 25, 29.

22. *http://www.tate.org.uk/britain/exhibitions/ kandinskyguggenheim/default.shtm,* accessed 21 April 2009.

23. Michael Fried first analyzed the language-like syntax of Caro's work in "Anthony Caro" (1963), reprinted in *Art and Objecthood: Essays and Reviews* (Chicago, 1998), 269.

24. Leo Steinberg, "The Glorious Company," in Jean Lipman and Richard Marshall, *Art about Art* (New York, 1978), 9, 17, 25, 31 n. 17.

25. Richard H. Axsom quoted on the Web site of the Madison Museum of Contemporary Art. *http://www.mmoca.org/ exhibitions/exhibitdetails/jasperjohns/ index.php*, accessed 13 May 2009.

26. Cited in Patrick S. Smith, *Andy Warhol's Art and Films* (Ann Arbor, 1981), 351.

27. Quoted in Richard Lacayo, "Picasso's Progeny" (9 October 2006), *http:// www.time.com/time/magazine/article/ 0,9171,1543942,00.html*, accessed 13 May 2009.

28. Roland Barthes, "Non Multa Sed Multum," trans. Henry Martin, in *Catalogue raisonné des oeuvres sur papier de Cy Twombly. 1973–1976* (Milan, 1979), 6:14.

29. Michel Pastoureau, *The Devil's Cloth: A History of Stripes and Striped Fabric*, trans. Jody Gladding (New York, 2001).

30. Sarah K. Rich, "The Proper Name of Newman's Zip," in *Reconsidering Barnett Newman* (Philadelphia Museum of Art, 2005), 96–114.

31. Yve-Alain Bois, *Painting as Model* (Cambridge, MA, 1990), 187–213. Newman said, "I feel that my zip does not divide my paintings. I feel it does the exact opposite." Interview with Emile de Antonio in John P. O'Neill, ed., *Barnett Newman: Selected Writings and Interviews* (New York, 1990), 306.

32. Bois 1990, 193.

33. Bois 1990, 157–183.

34. *The American Heritage Dictionary of the English Language*, 4th ed. (Boston, 2000). Updated in 2003. *http://www.thefree-dictionary.com/monochrome*, accessed 24 April 2009.

35. Kandinsky, *Concerning the Spiritual in Art*, cited in Lawrence Alloway, "Sign and Surface: Notes on Black and White Painting in New York," *Quadrum* 9 (1960): 62.

36. James Rondeau and Douglas Druick, *Jasper Johns: Gray* (Art Institute of Chicago, 2007).

37. Jacques Derrida, *Truth in Painting* (Chicago, 1987; French orig. 1978), 73.

38. "Every brushstroke that followed a fictive plane into fictive depth harked back… to the physical fact of the medium; and the shape and placing of that mark recalled the shape and position of the flat rectangle which was being covered with pigment that came from tubes." Greenberg 1951, 55.

39. The model of a newspaper (among others) was implicit in Leo Steinberg's description of Rauschenberg's work as a "flatbed picture plane," given that he borrowed the term from the flatbed printing press. Steinberg, "Other Criteria," in *Other Criteria* (London, 1972), 82.

Plates

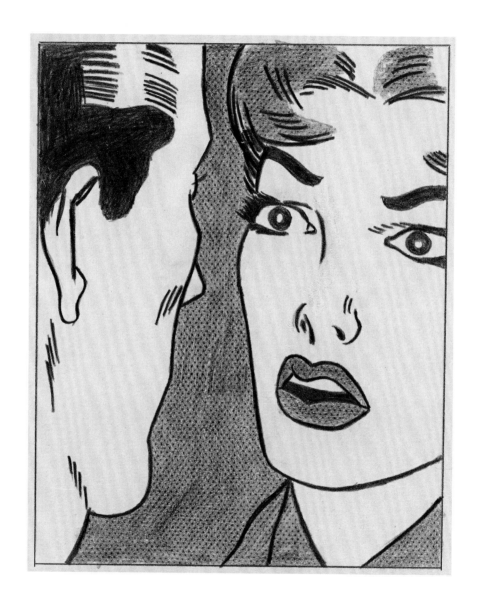

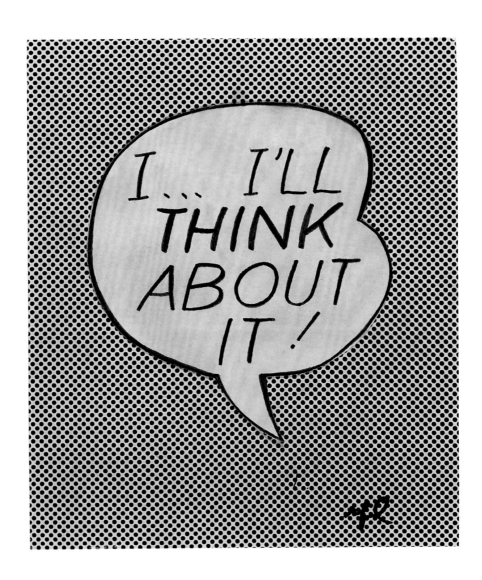

3.
Hans Hofmann,
Autumn Gold,
1957, oil on canvas,
52 ¼ × 60 ⅜ in.
(132.7 × 153.4 cm).
National Gallery
of Art, Collection of
Robert and Jane
Meyerhoff

4.
Jean Dubuffet,
Cote course mouche,
1961, oil on canvas,
44 ⅞ × 57 ½ in.
(114 × 146.1 cm)

5.
Willem de Kooning,
Untitled VI, 1983, oil
on canvas, 77 × 88 in.
(195.6 × 223.5 cm)

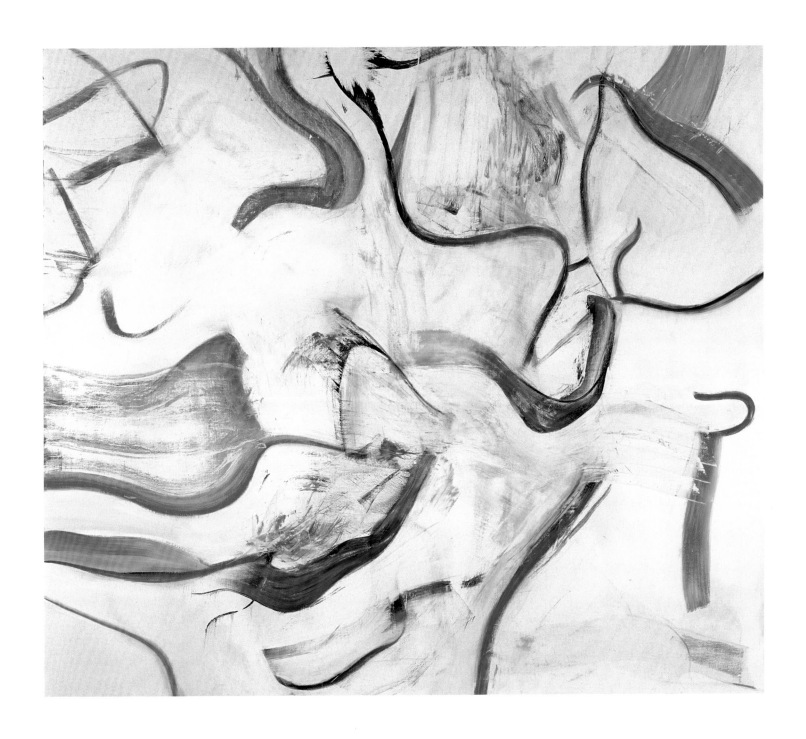

35 Scrape

6.
Clyfford Still, *1951–N*,
1951, oil on canvas,
92 ⁵⁄₁₆ × 69 ⅛ in.
(234.5 × 175.6 cm).
National Gallery
of Art, Collection of
Robert and Jane
Meyerhoff

12.
Kenneth Noland,
Mandarin, 1961,
acrylic on canvas,
82 ⅝ × 82 ½ in.
(209.9 × 209.6 cm)

13.
Josef Albers, *Homage to the Square*, 1950, oil and acrylic resin on wood fiberboard panel, 18 × 18 in. (45.7 × 45.7 cm)

14.
Richard Serra, *Torus IV*, 2000, Paintstick on paper, 30 × 32 ½ in. (76.2 × 82.6 cm)

15.
Jasper Johns, *Mirror's Edge 2*, 1993, encaustic on canvas, 66 × 44 ⅛ in. (167.6 × 112.1 cm)

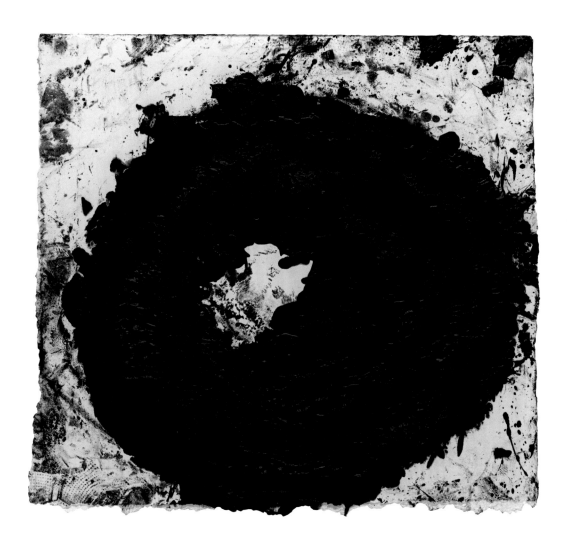

16.
Frank Stella, *Gray
Scramble*, 1969,
alkyd on canvas,
69 ⅛ × 69 ⅛ in.
(175.6 × 175.6 cm)

17.
Ellsworth Kelly,
Red Curve, 1987,
oil on canvas,
42 ⅛ × 205 ¾ in.
(107 × 522.6 cm)

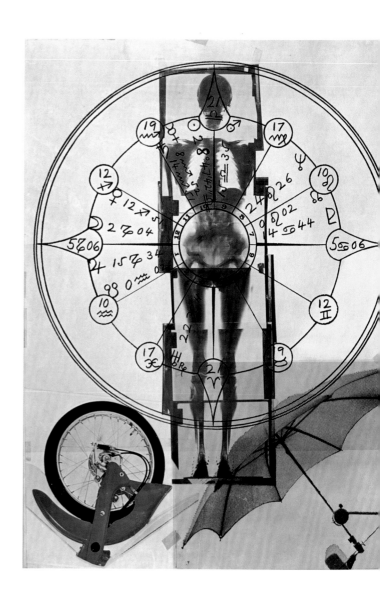

20.
Frank Stella, *Marquis de Portago* (first version), 1960, aluminum oil paint on canvas, 93 ⅛ × 71 ⅜ in. (236.5 × 181.3 cm)

21.
Ellsworth Kelly, *Catalpa Leaf*, 1983, crayon on paper, 24 × 18 in. (61 × 45.7 cm)

22.
Robert Rauschenberg,
Frigate (Jammer),
1975, mixed-media
construction,
95 ½ × 18 × 14 ½ in.
(242.6 × 45.7 × 36.8 cm)

23.
Ellsworth Kelly,
Beanstalk, 1999,
graphite on paper,
116 ⅛ × 22 ¼ in.
(295 × 56.5 cm)

24.
Jean Dubuffet,
La ronde des images,
1977, acrylic on
paper mounted on
canvas, 98 × 142 in.
(248.9 × 360.7 cm).
National Gallery
of Art, Collection of
Robert and Jane
Meyerhoff

25.
Jean Dubuffet,
Personnage, 1960,
ink on paper,
12 ⅞ × 9 ⅞ in.
(32.7 × 25.1 cm)

26.
Roberto Matta,
Untitled, c. 1958,
crayon and ink on
paper, 14 ½ × 21 ½ in.
(36.8 × 54.6 cm)

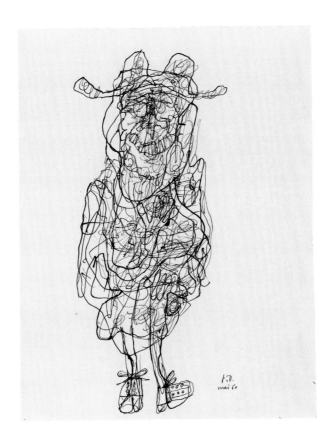

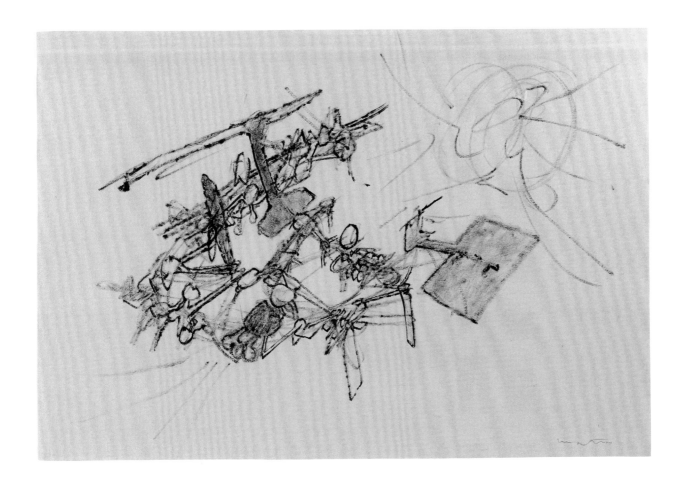

53 Line

27.
Willem de Kooning,
Two Women, 1952,
charcoal on paper,
22 ½ × 28 ½ in.
(57.2 × 72.4 cm).
Collection of the
Robert and Jane
Meyerhoff Modern
Art Foundation

28.
Philip Guston,
Untitled, 1969,
charcoal on paper,
18 × 24 in.
(45.7 × 61 cm)

29.
Agnes Martin,
Field #2, 1963, oil and
graphite on canvas,
74 ⅞ × 74 ⅞ in.
(190.2 × 190.2 cm).
Collection of the
Robert and Jane
Meyerhoff Modern
Art Foundation

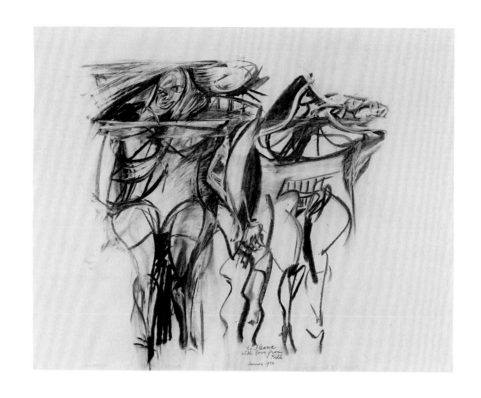

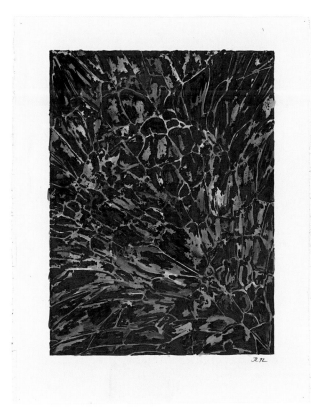

30.
Kenneth Noland, *Via Breeze II*, 1968, acrylic on canvas, 28 × 180 in. (71.1 × 457.2 cm)

31.
Brice Marden, *Long Drawing*, 1993/1996, ink and gouache on paper, 9 ¾ × 38 ½ in. (24.8 × 97.8 cm)

32.
Julian Lethbridge, *Untitled*, 1992, acrylic and graphite on paper, 28 ½ × 22 ½ in. (72.4 × 57.2 cm)

33.
Mel Bochner, *First
Fulcrum*, 1975, pastel
and conté crayon on
paper, 38 ⅛ × 50 in.
(96.8 × 127 cm).
National Gallery
of Art, Collection of
Robert and Jane
Meyerhoff

34.
Frank Stella,
Flin Flon IV, 1969,
polymer and
fluorescent polymer
paint on canvas,
96 ½ × 96 ½ in.
(245.1 × 245.1 cm).
National Gallery
of Art, Collection of
Robert and Jane
Meyerhoff

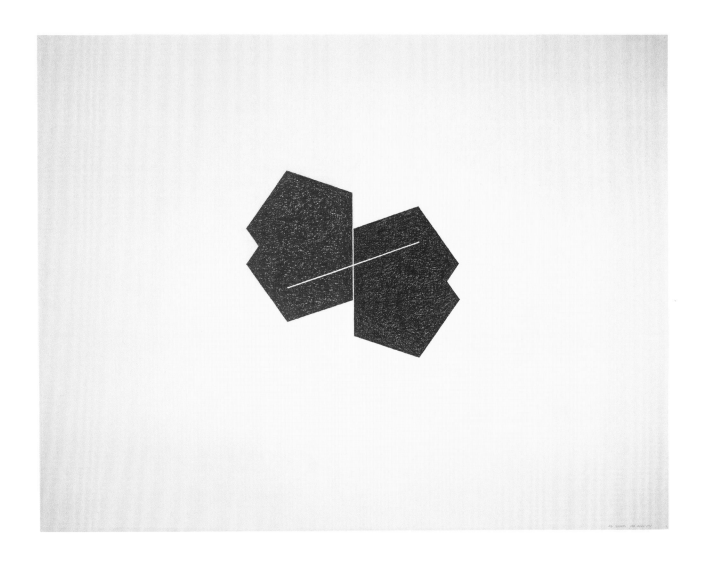

Mel Bochner, *First
Fulcrum,* 1975, pastel

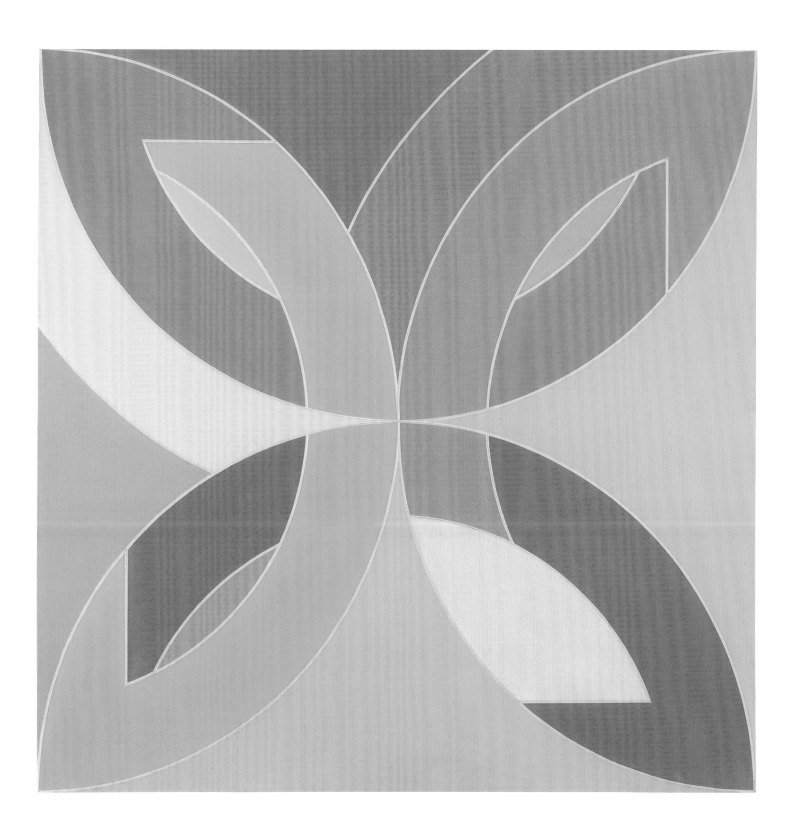

35.
Andy Warhol, *Small
Campbell's Soup
Can, 19¢*, 1962, alumi-
num paint and
synthetic polymer
paint silkscreened
on canvas, 20 × 16 in.
(50.8 × 40.6 cm).
Collection of the
Robert and Jane
Meyerhoff Modern
Art Foundation

36.
Roy Lichtenstein,
Sleeping Muse, 1983,
patinated bronze,
25 ⅝ × 34 ⅛ × 4 in.
(65.1 × 86.7 × 10.2 cm)

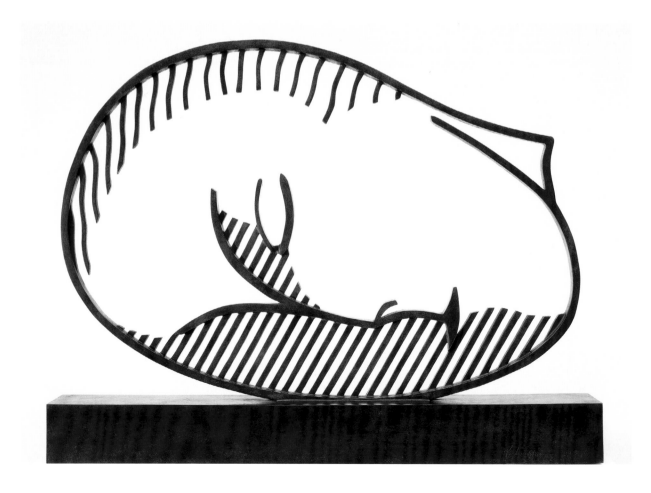

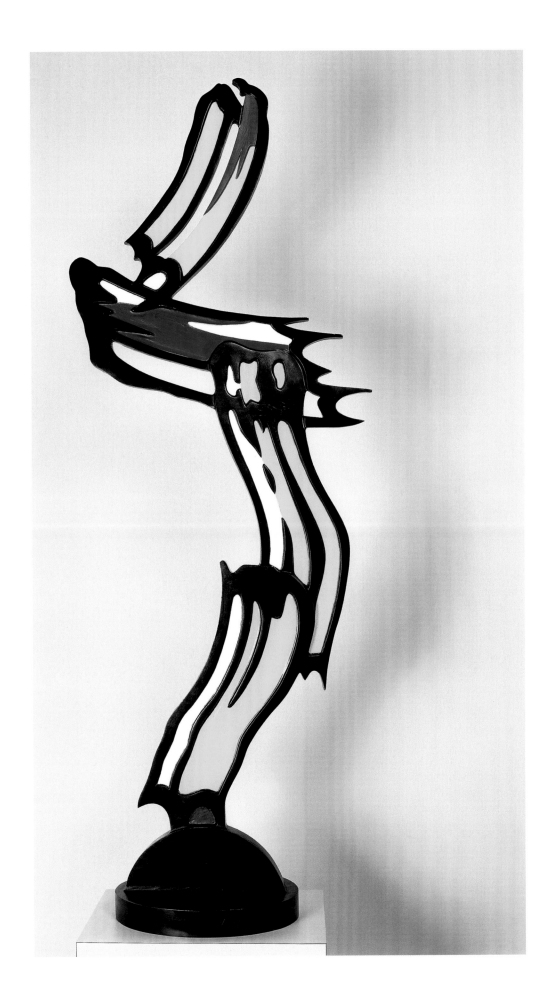

37.
Roy Lichtenstein,
Brushstrokes in Flight,
1983, painted and
patinated bronze,
55 ¼ × 21 × 10 in.
(140.3 × 53.3 × 25.4 cm)

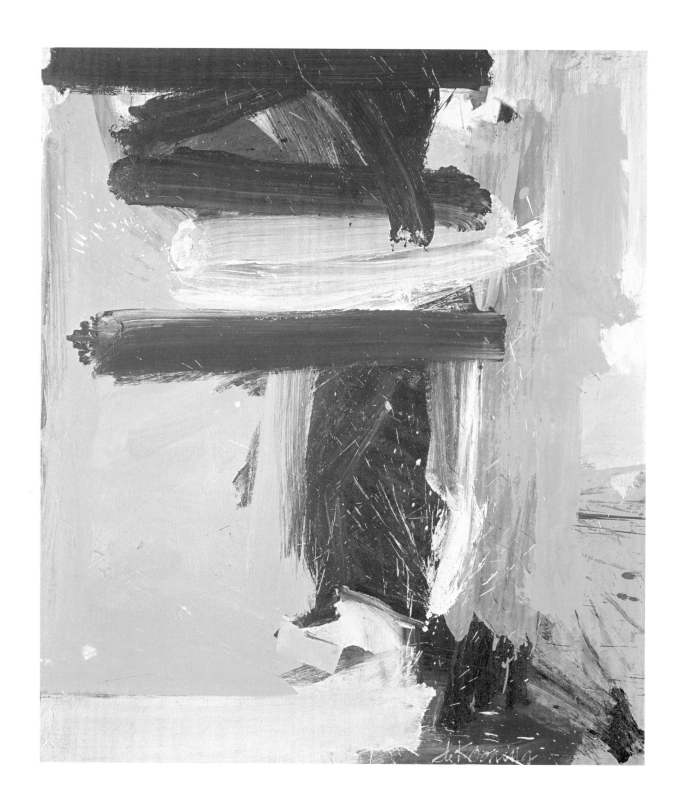

38.
Willem de Kooning,
Spike's Folly II,
1960, oil on canvas,
80 × 70 in.
(203.2 × 177.8 cm).
Collection of the
Robert and Jane
Meyerhoff Modern
Art Foundation

39.
Franz Kline, *Turbin*,
1959, oil and
enamel on canvas,
112 ½ × 77 ⅝ in.
(285.8 × 197.2 cm).
Collection of the
Robert and Jane
Meyerhoff Modern
Art Foundation

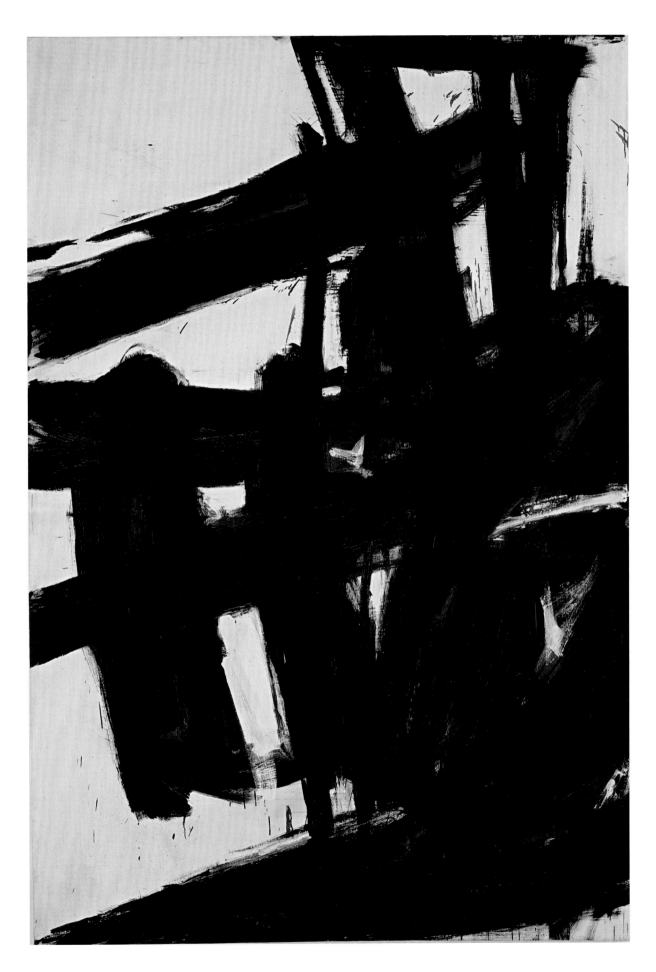

63 Gesture

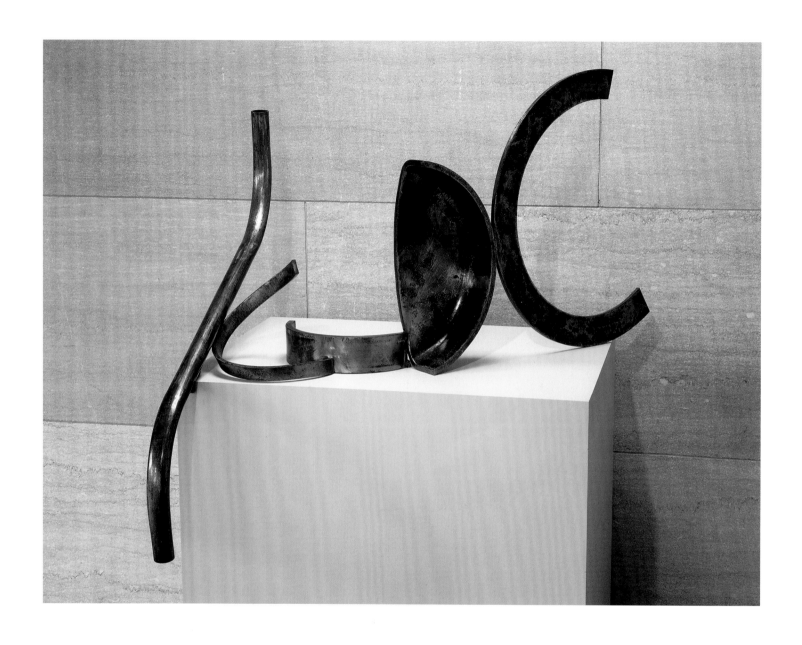

40.
Anthony Caro,
Table Piece LXX, 1968,
steel, 33 ½ × 51 × 25 in.
(85.1 × 129.5 × 63.5 cm).
National Gallery
of Art, Collection of
Robert and Jane
Meyerhoff

41.
Grace Hartigan,
Essex and Hester (Red),
1958, oil on canvas,
53 × 83 ¼ in.
(134.6 × 211.5 cm).
National Gallery
of Art, Collection of
Robert and Jane
Meyerhoff

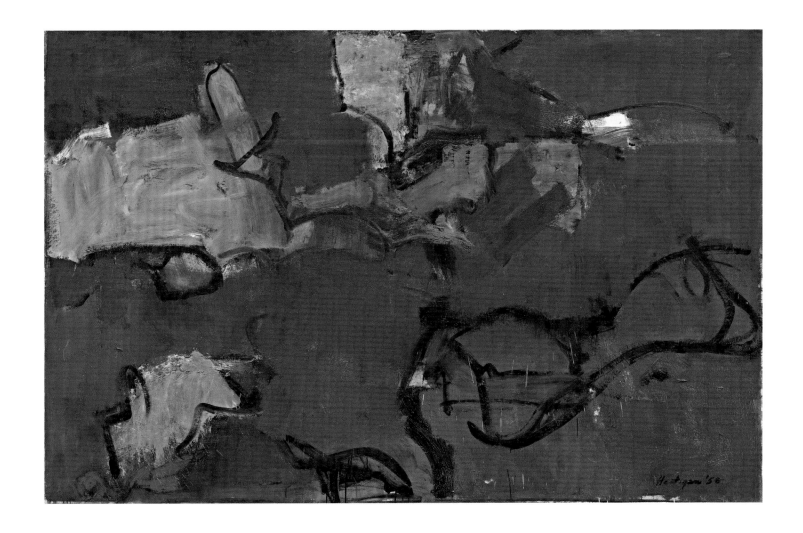

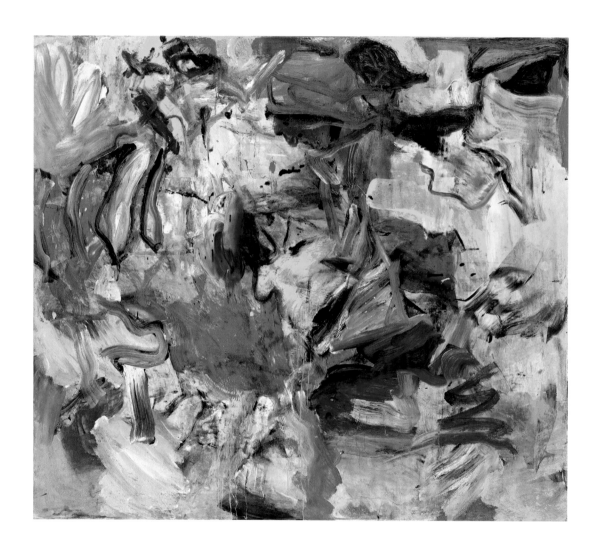

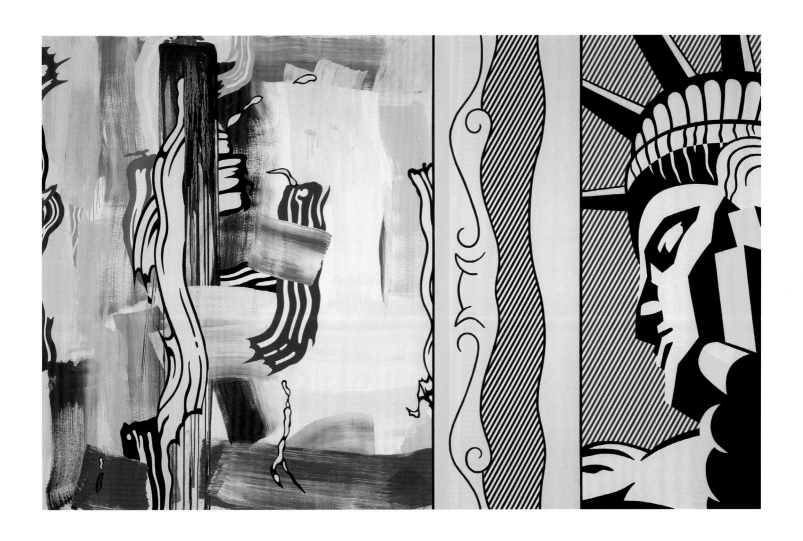

42.
Willem de Kooning,
Untitled, 1976–1977,
oil on canvas,
76 ½ × 87 ¾ in.
(194.3 × 222.9 cm).
Collection of the
Robert and Jane
Meyerhoff Modern
Art Foundation

43.
Roy Lichtenstein,
*Painting with Statue
of Liberty*, 1983, oil
and Magna on
canvas, 107 × 167 in.
(271.8 × 424.2 cm).
National Gallery
of Art, Collection of
Robert and Jane
Meyerhoff

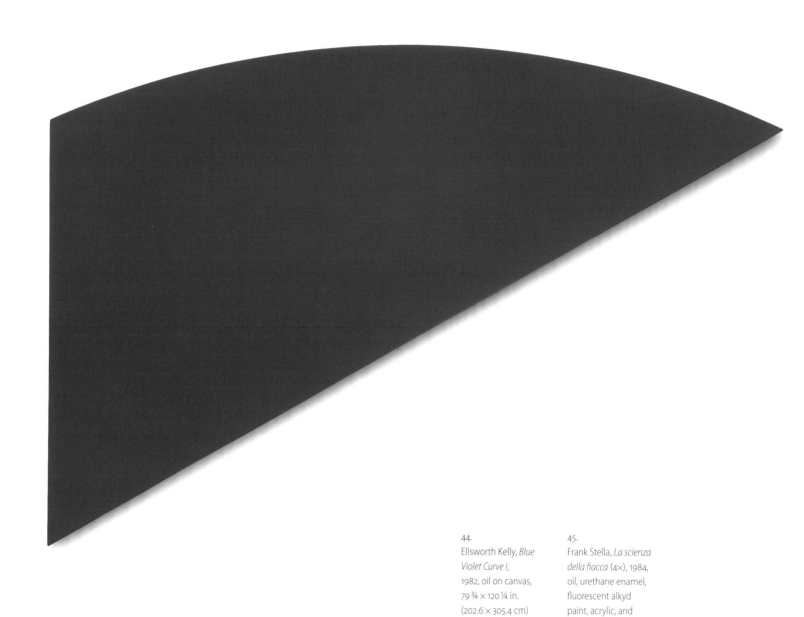

44.
Ellsworth Kelly, *Blue
Violet Curve I*,
1982, oil on canvas,
79 ¾ × 120 ¼ in.
(202.6 × 305.4 cm)

45.
Frank Stella, *La scienza
della fiacca* (4×), 1984,
oil, urethane enamel,
fluorescent alkyd
paint, acrylic, and
printing ink on can-
vas, etched mag-
nesium, aluminum,
and fiberglass, 143 ×
151 × 30 in. (363.2 ×
383.5 × 76.2 cm).
National Gallery
of Art, Collection of
Robert and Jane
Meyerhoff

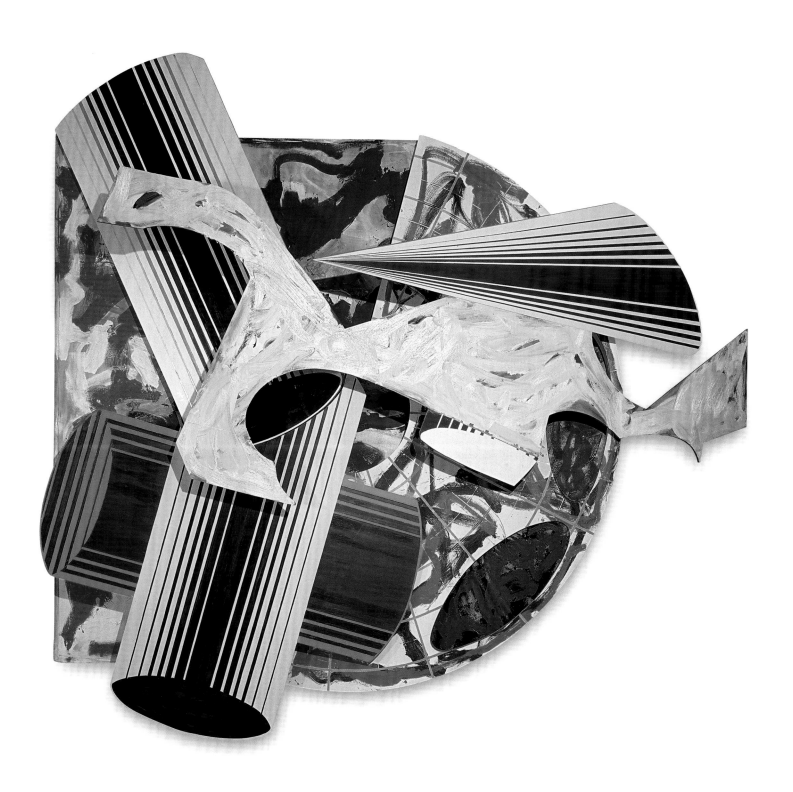

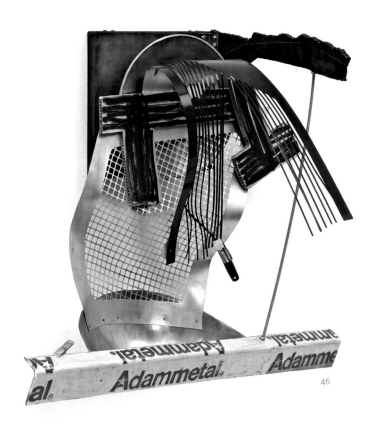

46

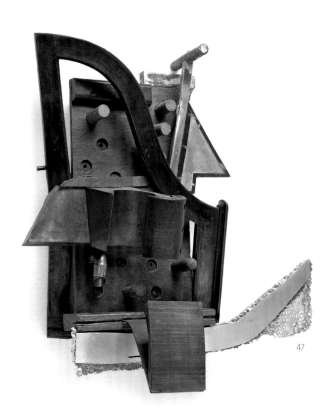

47

48

49

50

46.
Frank Stella, *Play-skool Screen*, 1983, hand-colored patinated bronze, fabricated aluminum, steel, etched honey-comb metal, and screenprinting, 42 ½ × 47 ½ × 35 in. (108 × 120.7 × 88.9 cm)

47.
Frank Stella, *Play-skool Chair*, 1983, hand-colored patinated bronze, fabricated aluminum, copper, wood dowels, etched magnesium, and honeycomb aluminum, 29 ¾ × 29 × 14 ¾ in. (75.6 × 73.7 × 37.5 cm)

48.
Frank Stella, *Play-skool Door*, 1983, hand-colored patinated bronze, fabricated aluminum, etched honeycomb magnesium, alumi-num screen, brass latch, and steel hinge, 32 × 24 × 17 in. (81.3 × 61 × 43.2 cm)

49.
Frank Stella, *Play-skool Sink*, 1983, hand-colored patinated bronze, fabricated aluminum, plastic, steel hose, hanger, cut wooden bowling pins, and plastic and metal bracket, 28 ½ × 36 × 29 in. (72.4 × 91.4 × 73.7 cm)

50.
Frank Stella, *Play-skool Bobbin*, 1983, hand-colored patinated bronze, wood, etched honey-comb aluminum, fiberglass, balsa wood laminate, plastic, and masking tape, 35 ¾ × 45 × 31 ½ in. (90.8 × 114.3 × 80 cm)

51.
Frank Stella, *Play-skool Hose*, 1983, hand-colored patinated bronze, wood, honeycomb aluminum, etched honeycomb magnesium, and rubber, 53 ¼ × 37 ¼ × 19 in. (135.3 × 94.6 × 48.3 cm)

52.
Frank Stella, *Play-skool Clamp,* 1983, hand-colored patinated bronze, fabricated aluminum, plastic, steel, etched honeycomb magnesium, and screenprinting, 36 × 24 × 20 in. (91.4 × 61 × 50.8 cm)

53.
Frank Stella, *Play-skool Gym,* 1983, hand-colored patinated bronze, fabricated aluminum, wood, steel, plastic, and screenprinting, 28 × 26 × 12 in. (71.1 × 66 × 30.5 cm)

Cats. 46–53 published by Tyler Graphics Ltd., Mt. Kisco, NY

51

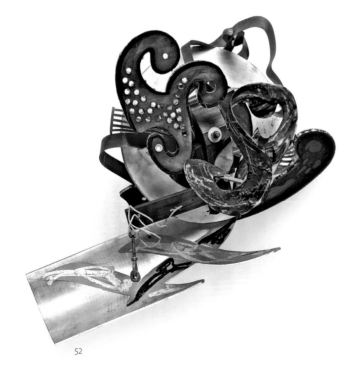

52

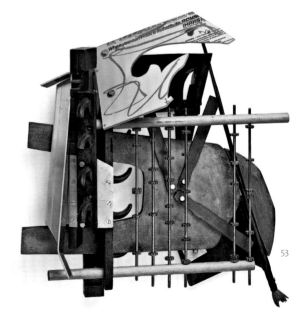

53

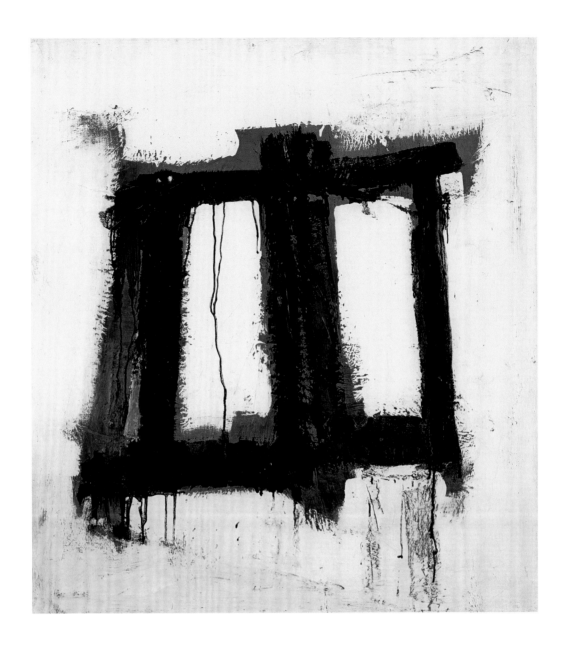

68.
Franz Kline, *Thorpe*,
1951, oil and
enamel on canvas,
37 ½ × 34 ½ in.
(95.3 × 87.6 cm)

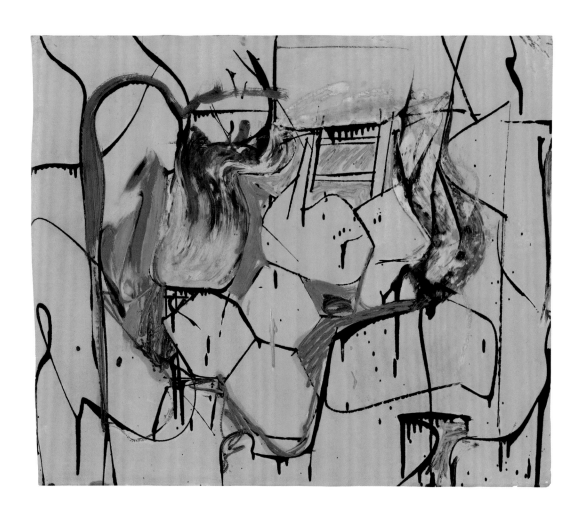

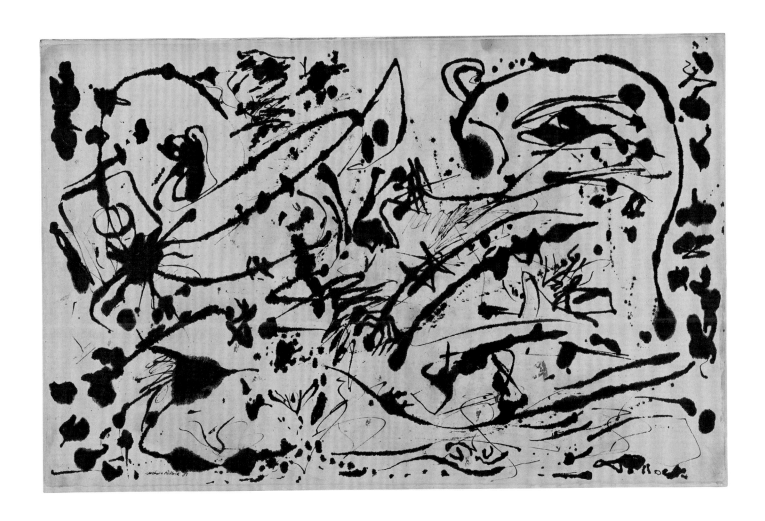

69.
Willem de Kooning,
Untitled, c. 1948–
1949, oil and
enamel on paper,
24 × 28 ¾ in.
(61 × 73 cm).
Collection of the
Robert and Jane
Meyerhoff Modern
Art Foundation

70.
Jackson Pollock,
Untitled, 1951, ink
on Japanese paper,
24 ¾ × 39 ½ in
(6

71.
Robert Rauschenberg,
Bypass, 1959, oil,
paper, metal, and
fabric on canvas,
59 ½ × 53 ¾ in.
(151.1 × 136.5 cm).
Collection of the
Robert and Jane
Meyerhoff Modern
Art Foundation

72.
Jasper Johns,
Perilous Night, 1982,
encaustic on
canvas with objects,
67 ⅛ × 96 ⅛ × 6 ¼ in.
(170.5 × 244.2 ×
15.9 cm). National
Gallery of Art, Collec-
tion of Robert and
Jane Meyerhoff

91 Drip

80.
Frank Stella, *Untitled*,
1958, gouache
on paper, 20 × 26 in.
(50.8 × 66 cm)

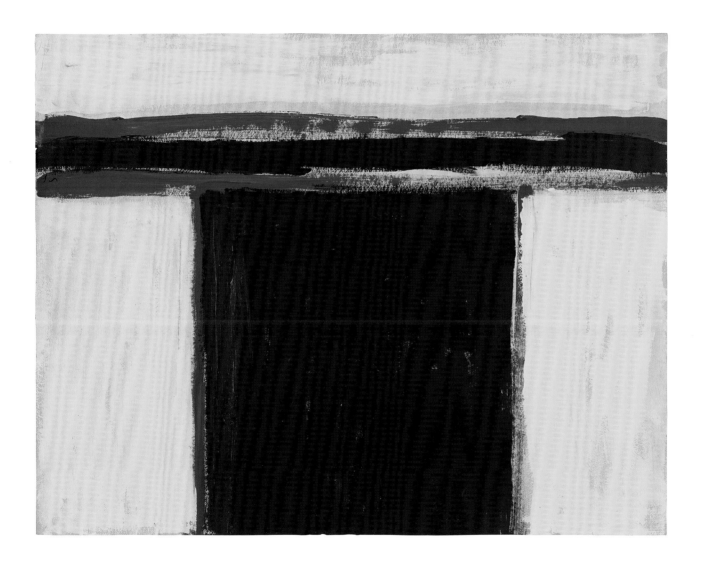

81.
Ellsworth Kelly,
Blue Yellow Red V,
1954/1987, oil on
canvas (three joined
panels), 97 7⁄8 × 75 in.
(248.6 × 190.5 cm)

82.
Brice Marden,
Cogitatio, 1978, oil
and wax on canvas
(four joined panels),
84 × 96 3⁄8 in.
(213.4 × 244.8 cm)

83.
Brice Marden,
Grove Group III, 1972–
1973/1980, oil and
wax on canvas
(three joined panels),
72 × 108 in.
(182.9 × 274.3 cm)

84.
Mark Rothko, *No. 3
(Bright Blue, Brown,
Dark Blue on Wine)*,
1962, mixed media on
canvas, 81 × 76 ¼ in.
(205.7 × 193.7 cm)

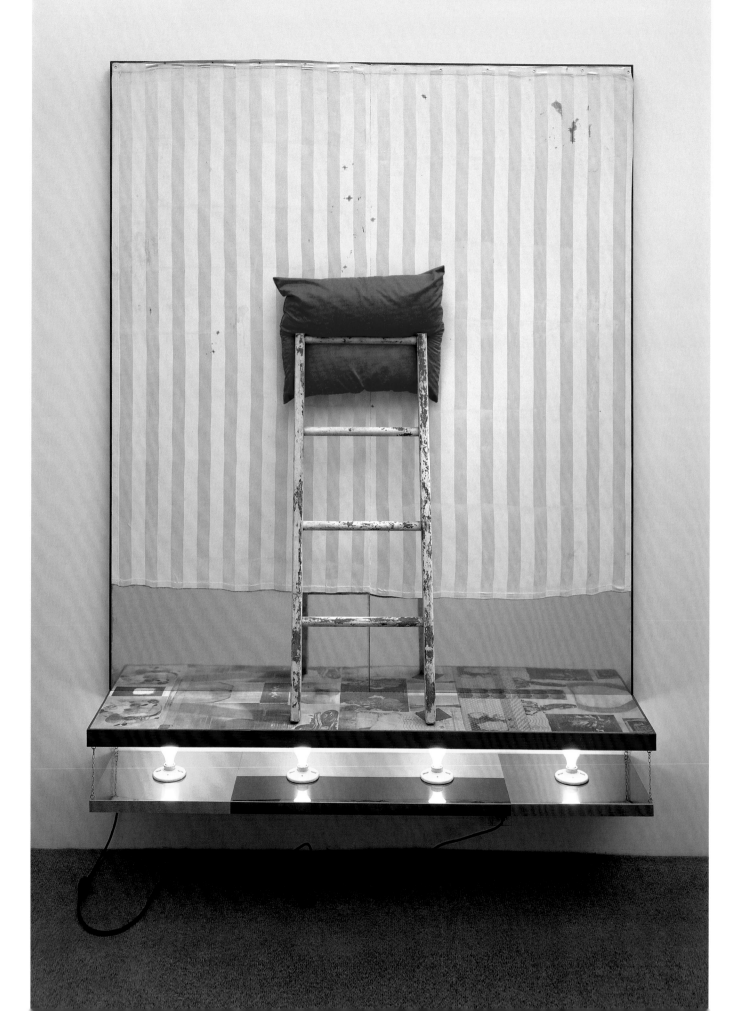

87.
Robert Rauschenberg,
Rose Condor (Scale),
1977, solvent transfer,
fabric, acrylic sheet,
Mylar, and objects on
plywood construction
with electric circuitry,
94 ¾ × 72 ¾ × 15 ⅜ in.
(240.7 × 184.8 ×
39.1 cm)

88.
Roy Lichtenstein,
Entablature, 1975, oil,
sand, and Magna
on canvas, 66 x 112 in.
(167.6 x 284.5 cm).
National Gallery
of Art, Collection of
Robert and Jane
Meyerhoff

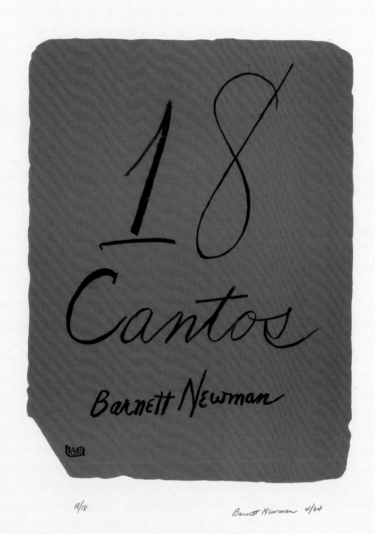

18/18 Barnett Newman 4/64

To Annalee

I should say that it was the margins made in printing a lithographic stone that magnetized the challenge that lithography has had for me from the very beginning. No matter what one does, no matter how completely one works the stone (and I have always worked the stone the same way I paint and draw–using the area–complete), the stone, as soon as it is printed, makes an imprint that is surrounded by inevitable white margins. I would create a totality only to find it change after it was printed–into another totality. Theoretically a lithograph consists of the separation between the imprint and the paper it is *on*. Unfortunately it never works that way for me. There is always the inevitable intrusion (in my lithograph at least) of the paper frame. To crop the extruding paper or to cover it with a mat or to eliminate all margins by "bleeding" (printing on papers smaller than the drawing on the stone) is an evasion of this fact. It is like cropping to make a painting. It is success by mutilation.

The struggle to overcome this intrusion–to give the imprint its necessary scale so that it could have its fullest expression, (and I feel that the matter of scale in a lithograph has usually not been considered) so that it would not be crushed by the paper margin and still have a margin–that was the challenge for me. That is why each canto has its own personal margins. In some, they are small, in others large, still in others they are larger on one side and the other side is minimal. However, no formal rules apply. Each print and its paper had to be decided by me and in some cases the same print exists with two different sets of margins because each imprint means something different to me. In painting, I try to transcend the size for the sake of scale. So here I was faced with the problem of having each imprint transcend not only its size but also the white frame to achieve this sense of scale.

These eighteen cantos are then single, individual expressions, each with its unique difference. Yet since they grew one out of the other, they also form an organic whole–so that as they separate and as they join in their interplay, their symphonic mass lends additional clarity to each individual canto, and at the same time, each canto adds its song to the full chorus.

I must explain that I had no plan to make a portfolio of "prints". I am not a printmaker. Nor did I intend to make a "set" by introducing superficial variety. These cantos arose from a compelling necessity–the result of grappling with the instrument.

To me that is what lithography is. It *is* an instrument. It is not a "medium"; it is not a poor man's substitute for painting or for drawing. Nor do I consider it to be a kind of translation of something from one medium into another. For me, it is an instrument that one plays. It is like a piano or an orchestra, and as with an instrument, it *interprets*. And as in all the interpretive arts, so in lithography, creation is joined with the "playing"; in this case not of bow and string, but of stone and press. The definition of a lithograph is that it is writing on stone. But unlike Gertrude Stein's rose, the stone is not a stone. The stone is a piece of paper.

I have been captivated by the things that happen in playing this litho instrument; the choices that develop when changing a color or the paper-size. I have "played" hoping to evoke every possible instrumental lick. The prints really started as three, grew to seven, then eleven, then fourteen, and finished as eighteen. Here are the cantos, eighteen of them, each one different in form, mood, color, beat, scale and key. There are no cadenzas. Each is separate. Each can stand by itself. But its fullest meaning, it seems to me, is when it is seen together with the others.

It remains for me to thank Cleve Gray for bringing me to lithography, particularly at the time he did, Tatyana Grosman for her devotion and encouragement and patience in my behalf and to Zigmunds Priede for his sympathetic cooperation on the press.

Barnett Newman

89 (a–t).
Barnett Newman,
18 Cantos, 1964, portfolio of 18 lithographs with title page and preface, published by Universal Limited Art Editions, West Islip, NY. National Gallery of Art, Collection of Robert and Jane Meyerhoff

89a.
Title Page,
25 ¼ × 19 ¾ in.
(64.1 × 50.2 cm)

89b.
Preface,
22 ½ × 17 ½ in.
(57.3 × 44.5 cm)

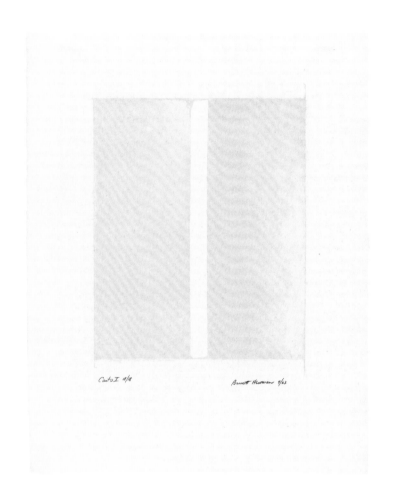

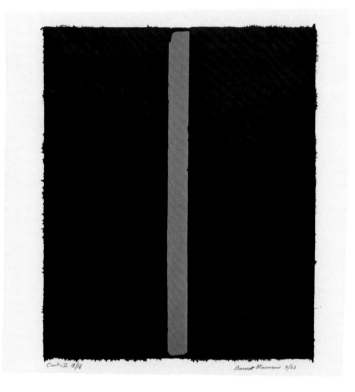

89c.
Canto I, 1963,
25 × 20 in.
(63.5 × 50.8 cm)

89d.
Canto II, 1963,
16 ⅜ × 15 ¾ in.
(41.6 × 40 cm)

89e.
Canto III, 1963,
19 ⅝ × 13 ¾ in.
(49.9 × 34.9 cm)

89f.
Canto IV, 1963,
20 ¼ × 13 ¾ in.
(51.4 × 34.9 cm)

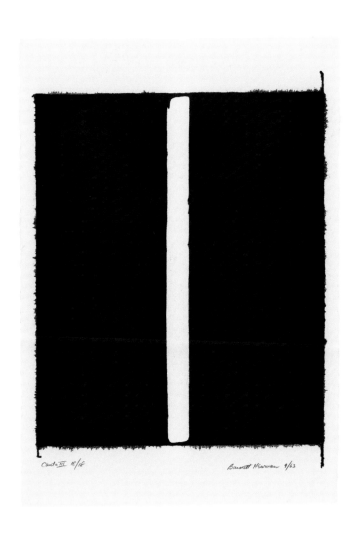

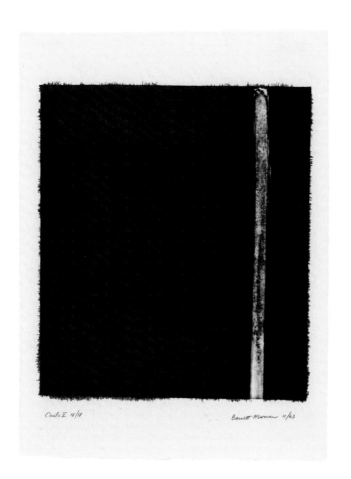

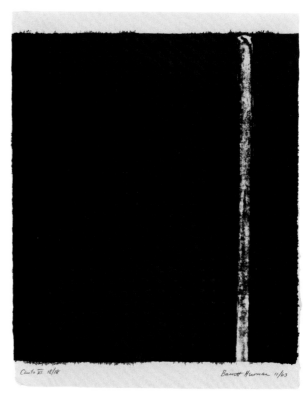

89g.
Canto V, 1963,
19 ½ × 14 ¾ in.
(49.5 × 37.5 cm)

89h.
Canto VI, 1963,
16 ½ × 12 ⅞ in.
(41.9 × 32.7 cm)

89i.
Canto VII, 1963,
16 ¼ × 15 ⅞ in.
(41.3 × 40.3 cm)

89j.
Canto VIII, 1963,
17 ¾ × 15 ⅛ in.
(45.1 × 38.4 cm)

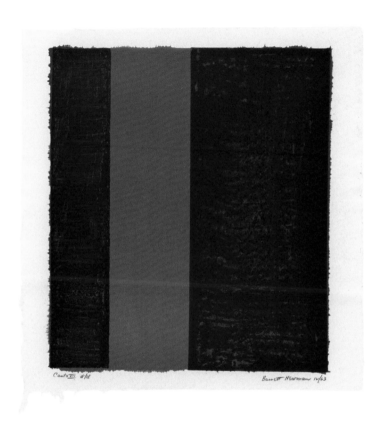

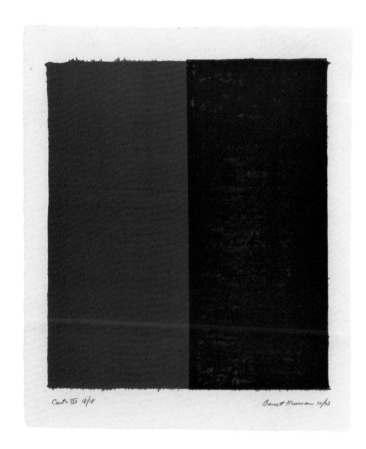

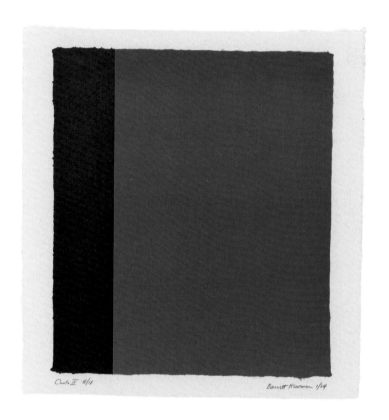

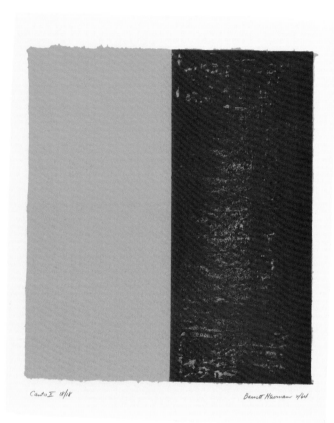

89k.
Canto IX, 1963–1964,
16 ⅜ × 15 ¾ in.
(41.6 × 40 cm)

89l.
Canto X, 1964,
17 ¾ × 14 ⁹⁄₁₆ in.
(45.1 × 37 cm)

89m.
Canto XI, 1964,
17 ⅝ × 14 ⅝ in.
(44.8 × 37.2 cm)

89n.
Canto XII, 1964,
17 ⅝ × 14 ⅜ in.
(44.8 × 36.5 cm)

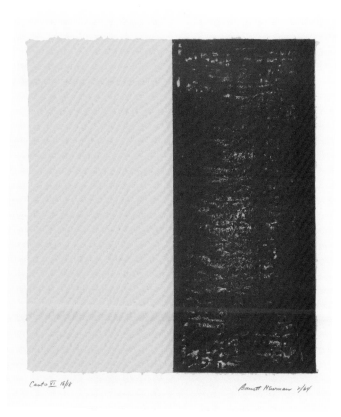

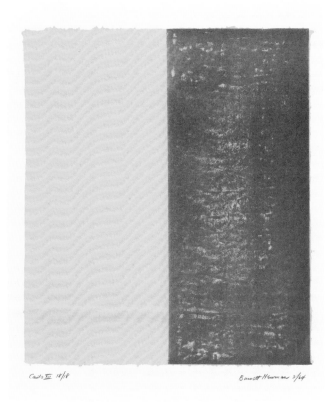

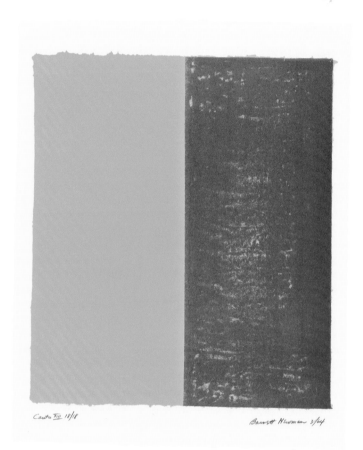

Canto VIII 18/18 Barnett Newman 3/64

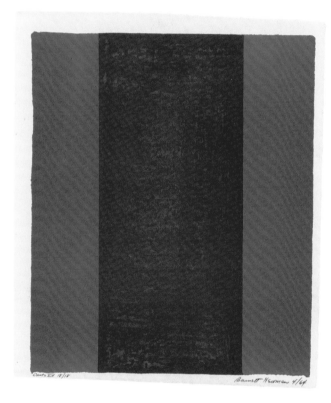

Canto IX 18/18 Barnett Newman 4/64

89o.
Canto XIII, 1964,
17 ¾ × 14 ½ in.
(45.1 × 36.8 cm)

89p.
Canto XIV, 1964,
15 ¾ × 13 ½ in.
(40 × 34.3 cm)

89q.
Canto XV, 1964,
15 ½ × 13 ¾ in.
(39.4 × 34.9 cm)

89r.
Canto XVI, 1964,
17 ½ × 13 ⅝ in.
(44.5 × 34.6 cm)

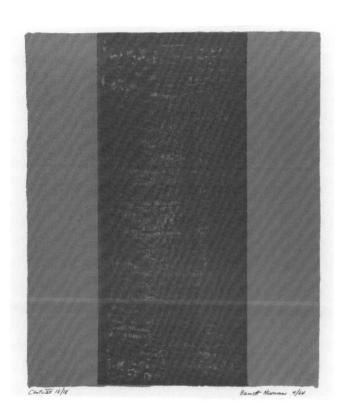

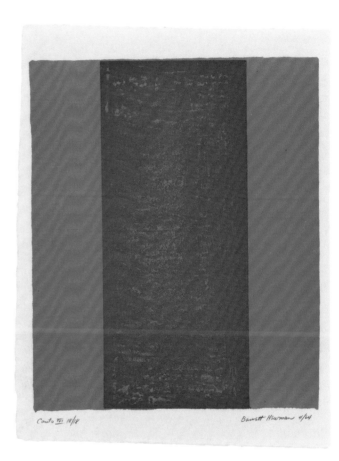

89s.
Canto XVII, 1964,
17 5/8 × 13 1/16 in.
(44.8 × 33.2 cm)

89t.
Canto XVIII, 1964,
25 × 19 1/2 in.
(63.5 × 49.5 cm)

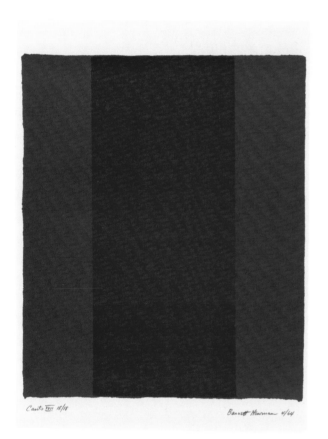

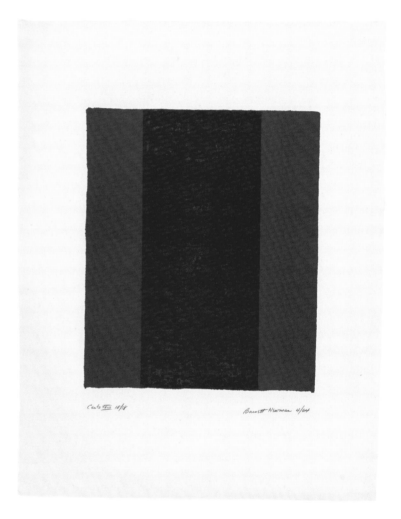

90.
Brice Marden, *6 Red Rock* 1, 2000–2002, oil on linen, 107 × 75 in. (271.8 × 190.5 cm)

91.
Jean Dubuffet,
Compagnie fallacieuse,
1963, oil on canvas,
44 7/8 × 57 1/2 in.
(114 × 146.1 cm)

92.
Terry Winters,
Graphics Tablet, 1998,
oil and alkyd resin
on canvas, 96 × 120 in.
(243.8 × 304.8 cm)

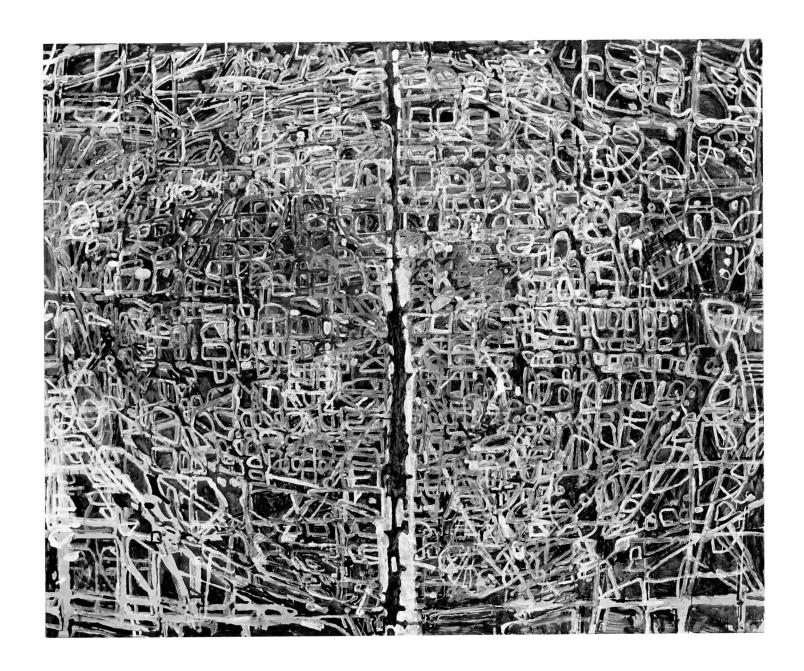

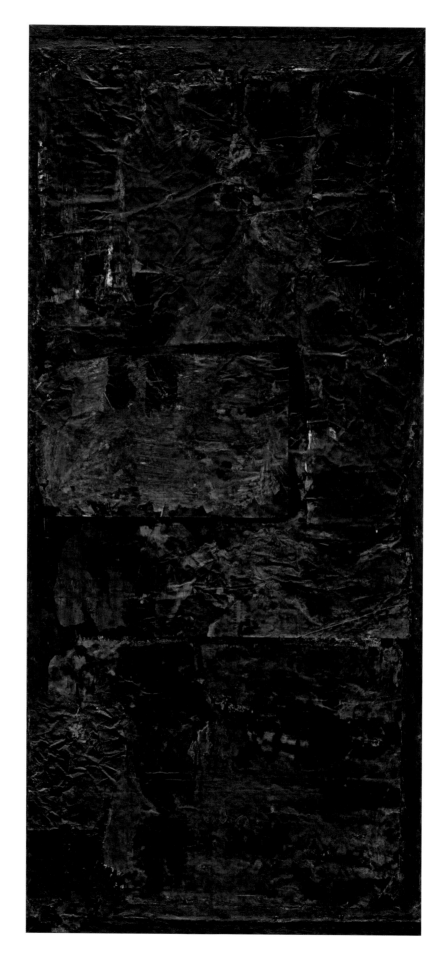

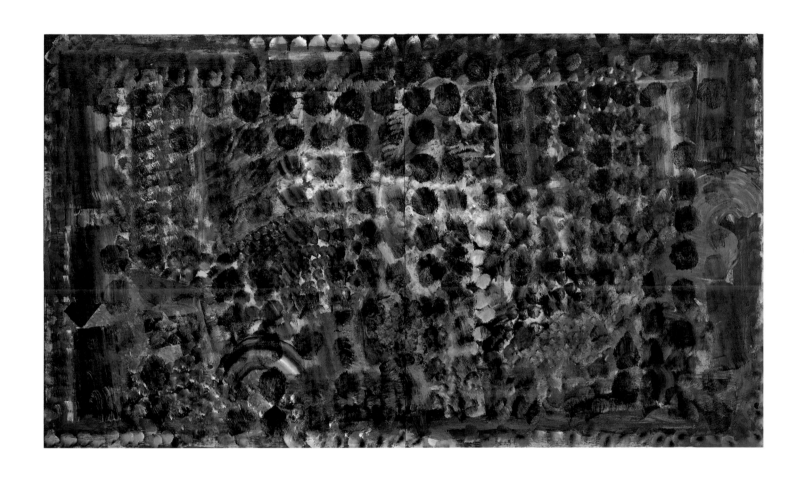

97.
Roy Lichtenstein,
Painting with Detail,
1987, oil and Magna on
canvas (two panels),
left panel: 60 x 48 in.
(152.4 x 121.9 cm),
right panel:
17 ¼ × 17 ⅛ in.
(43.8 × 43.5 cm)

98.
Howard Hodgkin,
Souvenirs, 1980–1984,
oil on wood
(two joined panels),
60 × 108 in.
(152.4 × 274.3 cm).
National Gallery
of Art, Collection of
Robert and Jane
Meyerhoff

99.
Ad Reinhardt,
Untitled (Yellow and White), 1950, oil on canvas, 80 × 60 in. (203.2 × 153.4 cm). National Gallery of Art, Collection of Robert and Jane Meyerhoff

100.
Ad Reinhardt, *Untitled (Red and Gray),* 1950, oil on canvas, 80 × 60 in. (203.2 × 153.4 cm). National Gallery of Art, Collection of Robert and Jane Meyerhoff

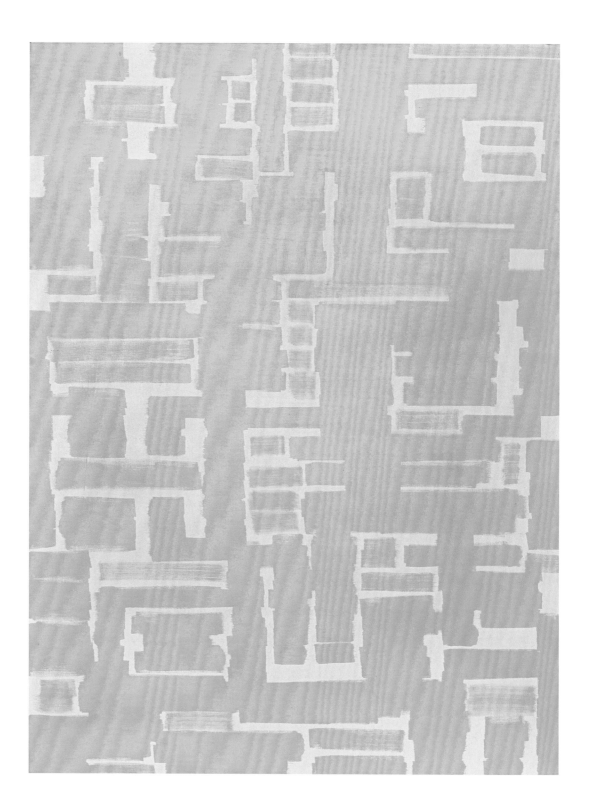

101.
Jackson Pollock,
Ritual, 1953,
oil on canvas,
90 ½ × 42 ½ in.
(229.9 × 108 cm)

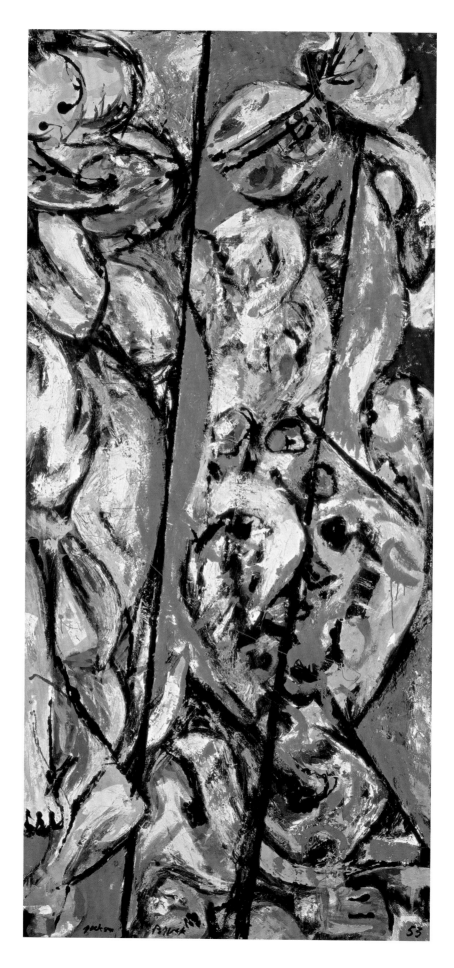

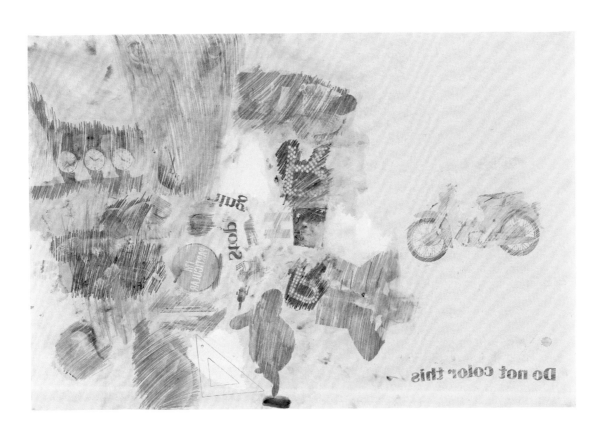

102.
Robert Rauschenberg,
Decoder III, 1965,
solvent transfer,
graphite, colored
pencil, and gouache
on paper, 24 × 36 in.
(61 × 91.4 cm)

103.
Jasper Johns, *Night Driver*, 1960, charcoal, pastel, and collage on paper, 51 × 42 ⅛ in. (129.5 × 107 cm)

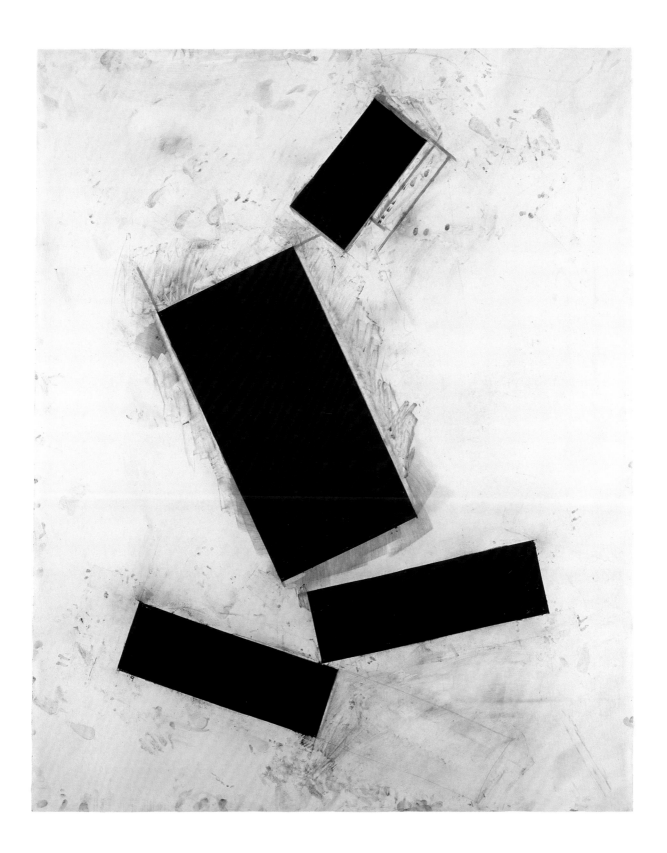

113.
Burgoyne Diller,
First Theme, 1964, oil
on canvas, 42 × 42 in.
(106.7 × 106.7 cm).
National Gallery
of Art, Collection
of Robert and
Jane Meyerhoff

114.
Ellsworth Kelly,
*Chatham III: Black
Blue,* 1971, oil on
canvas (two joined
panels), 108 × 96 in.
(274.3 × 243.8 cm)

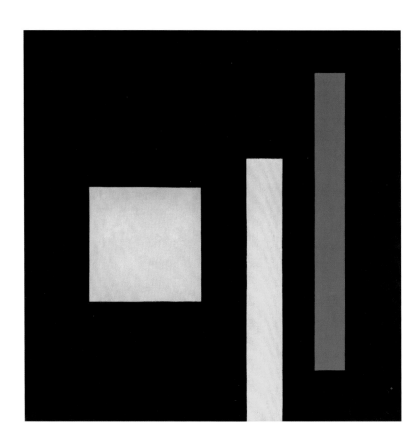

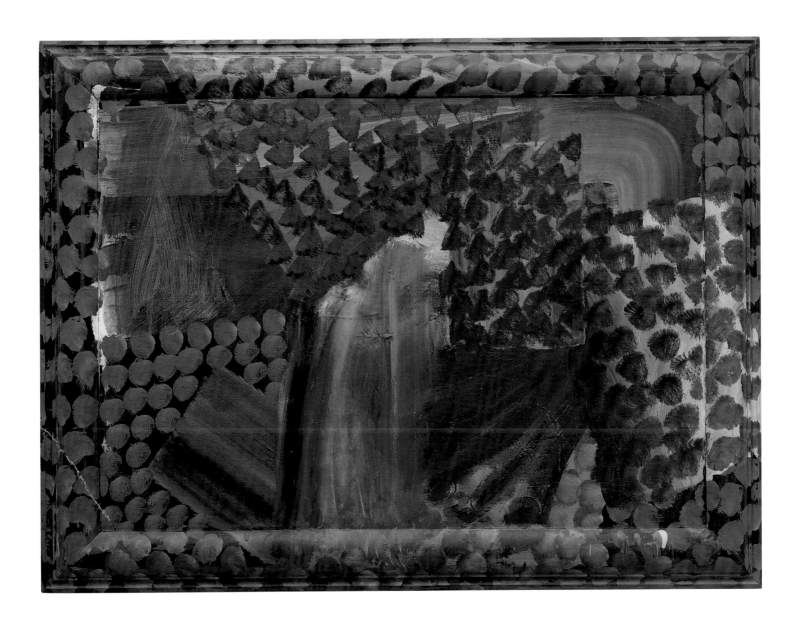

121.
Roy Lichtenstein,
Reflections: Nurse,
1988, oil and
Magna on canvas,
57 ¼ × 57 ¼ in.
(145.4 × 145.4 cm)

122.
Howard Hodgkin,
Old Money, 1987–1989,
oil on wood,
39 ½ × 53 ⅛ in.
(100.3 × 134.9 cm)

Anfam, David. *Abstract Expressionism.* London, 1990.

Arnheim, Rudolf. *The Power of the Center: A Study of Composition in the Visual Arts.* Berkeley, 1982.

Bader, Graham, ed. *Roy Lichtenstein.* Cambridge, MA, 2009.

Bois, Yve-Alain, et al. *Abstraction Gesture Ecriture: Paintings from the Daros Collection.* Zurich, 1999.

———. *Ellsworth Kelly: The Early Drawings, 1948–1955.* Harvard University Art Museums, Cambridge, MA, 1999.

———, et al. *Ellsworth Kelly: The Years in France, 1948–1954.* National Gallery of Art, Washington, 1992.

———. "Marden's Doubt." In *Brice Marden: Paintings 1985–1993,* 12–67. Kunsthalle Bern, 1993.

———. *Painting as Model.* Cambridge, MA, 1990.

Brodie, Judith, and Andrew Robison, eds. *A Century of Drawing: Works on Paper from Degas to LeWitt.* National Gallery of Art, Washington, 2001.

Carmean, E. A., Jr., and Eliza E. Rathbone. *American Art at Mid-Century: The Subjects of the Artist.* National Gallery of Art, Washington, 1978.

Castleman, Riva. *Jasper Johns: A Print Retrospective.* The Museum of Modern Art, New York, 1986.

Clark, T. J. *Farewell to an Idea: Episodes from a History of Modernism.* New Haven, 1999.

Cooper, Harry. *An Intense Detachment: Ellsworth Kelly's "Line Form Color."* Vol. 1 of Ellsworth Kelly, *Line Form Color.* Harvard University Art Museums, Cambridge, MA, 1999.

———. "Marden Attendant." In *Brice Marden,* 9–27. Serpentine Gallery, London, 2000.

———. "Speak, Painting: Word and Device in Early Johns." *October* 127 (Winter 2009): 49–76.

———, and Megan R. Luke. *Frank Stella 1958.* Harvard University Art Museums, Cambridge, MA, 2006.

Coplans, John. *Serial Imagery.* The New York Graphic Society, 1968.

Cowart, Jack. *Roy Lichtenstein 1970–1980.* New York, 1981.

Crow, Thomas. *The Rise of the Sixties: American and European Art in the Era of Dissent.* New York, 1996.

Danto, Arthur C. *After the End of Art: Contemporary Art and the Pale of History.* The A. W. Mellon Lectures in the Fine Arts, 1995. Princeton, 1997.

de Antonio, Emile, and Mitch Tuchman. *Painters Painting: A Candid History of the Modern Art Scene, 1940–1970.* New York, 1984.

Diamonstein, Barbaralee. *Inside the Art World: Conversations with Barbaralee Diamonstein.* New York, 1994.

Elderfield, John, ed. *American Art of the 1960s.* The Museum of Modern Art, New York, 1991.

Feinstein, Roni. *Robert Rauschenberg: The Silkscreen Paintings 1962–1964.* Whitney Museum of American Art, New York, 1990.

Field, Richard S. *The Prints of Jasper Johns 1960–1993: A Catalogue Raisonné.* West Islip, NY, 1994.

Fine, Ruth E. *Gemini G.E.L.: Art and Collaboration.* National Gallery of Art, Washington, 1984.

Fineberg, Jonathan. *Art Since 1940: Strategies of Being.* 2nd ed. New York, 2000.

Fitzgerald, Michael. *Picasso and American Art.* Whitney Museum of American Art, New York, 2006.

Foster, Hal, et al. *Art Since 1900: Modernism, Antimodernism, Postmodernism.* 2 vols. New York, 2004.

Frascina, Francis, and Charles Harrison. *Modern Art and Modernism: A Critical Anthology.* New York, 1982.

Fried, Michael. *Art and Objecthood: Essays and Reviews.* Chicago, 1998.

———. *Three American Painters: Kenneth Noland, Jules Olitski, Frank Stella.* Fogg Art Museum, Cambridge, MA, 1965.

Garrels, Gary. *Plane Image: A Brice Marden Retrospective.* The Museum of Modern Art, New York, 2006.

Geldzahler, Henry. *New York Painting and Sculpture: 1940–1970*. New York, 1969.

Greenberg, Clement. *Art and Culture: Critical Essays*. Boston, 1961.

Harrison, Charles, and Paul Wood, eds. *Art in Theory 1900–1990: An Anthology of Changing Ideas*. Oxford, 1992.

Hopps, Walter. *Rauschenberg: The Early 1950s*. Menil Collection, Houston, 1991.

———, and Susan Davidson. *Robert Rauschenberg: A Retrospective*. The Solomon R. Guggenheim Museum, New York, 1997.

Hughes, Robert. *The Shock of the New*. New York, 1991.

Hunter, Sam. *Robert Rauschenberg: Works, Writings, and Interviews*. Barcelona, 2006.

Jones, Caroline A. *Machine in the Studio: Constructing the Postwar American Artist*. Chicago, 1996.

Joseph, Branden W. *Random Order: Robert Rauschenberg and the Neo-Avant-Garde*. Cambridge, MA, 2003.

———, ed. *Robert Rauschenberg*. Cambridge, MA, 2002.

Kertess, Klaus. *Brice Marden: Paintings and Drawings*. New York, 1992.

Kleeblatt, Norman L., ed. *Action / Abstraction: Pollock, De Kooning, and American Art, 1940–1976*. The Jewish Museum, New York, 2008.

Krauss, Rosalind. *The Optical Unconscious*. Cambridge, MA, 1993.

Leja, Michael. *Reframing Abstract Expressionism: Subjectivity and Painting in the 1940s*. New Haven, 1993.

Lipman, Jean, and Richard Marshall. *Art About Art*. Introduction by Leo Steinberg. New York, 1978.

Mattison, Robert Saltonstall. *Masterworks in the Robert and Jane Meyerhoff Collection: Jasper Johns, Robert Rauschenberg, Roy Lichtenstein, Ellsworth Kelly, Frank Stella*. New York, 1995.

Morphet, Richard. *Encounters: New Art from Old*. Introduction by Robert Rosenblum. National Gallery, London, 2000.

O'Doherty, Brian. *American Masters: The Voice and the Myth in Modern Art*. New York, 1982.

———. *Inside the White Cube: The Ideology of the Gallery Space*. San Francisco, 1986.

Pastoureau, Michel. *The Devil's Cloth: A History of Stripes and Striped Fabric*. Translated by Jody Gladding. New York, 1991.

Porter, Fairfield. *Art in Its Own Terms: Selected Criticism 1935–1975*. Cambridge, MA, 1993.

Richardson, Brenda. *Brice Marden: Cold Mountain*. The Menil Collection, Houston, 1992.

Rishel, Joseph J., and Katherine Sachs. *Cézanne and Beyond*. Philadelphia Museum of Art, 2009.

Rondeau, James, and Douglas Druick. *Jasper Johns: Gray*. The Art Institute of Chicago, 2007.

Rose, Bernice. *The Drawings of Roy Lichtenstein*. The Museum of Modern Art, New York, 1987.

Rosenberg, Harold. *The Tradition of the New*. New York, 1961.

Rosenthal, Mark. *Abstraction in the Twentieth Century: Total Risk, Freedom, Discipline*. The Solomon R. Guggenheim Museum, New York, 1996.

———. *The Robert and Jane Meyerhoff Collection: 1945 to 1995*. National Gallery of Art, Washington, 1996.

Rosenthal, Nan, and Ruth E. Fine. *The Drawings of Jasper Johns*. National Gallery of Art, Washington, 1990.

Rosenthal, Stephanie. *Black Paintings*. Haus der Kunst, Munich, 2006.

Rubin, Lawrence. *Frank Stella: Paintings, 1958 to 1965: A Catalogue Raisonné*. Introduction by Robert Rosenblum. New York, 1986.

Rubin, William S. *Frank Stella*. The Museum of Modern Art, New York, 1970.

Sandler, Irving. *The Triumph of American Painting: A History of Abstract Expressionism*. New York, 1970.

Schapiro, Meyer. *Modern Art, 19th and 20th Centuries: Selected Papers*. New York, 1978.

Steinberg, Leo. *Other Criteria: Confrontations with Twentieth-Century Art*. New York, 1972.

Stella, Frank. *Working Space: The Charles Eliot Norton Lectures, 1983–1984*. Cambridge, MA, 1986.

Sundell, Nina. *The Robert + Jane Meyerhoff Collection: 1958–1979*. Baltimore, 1980.

Sylvester, David. *About Modern Art: Critical Essays, 1948–1997*. New York, 1997.

———. *Interviews with American Artists*. New Haven, 2001.

———, et al. *Willem de Kooning: Paintings*. National Gallery of Art, Washington, 1994.

Temkin, Ann. *Barnett Newman*. Philadelphia Museum of Art, 2002.

Tomkins, Calvin. *Off the Wall: Robert Rauschenberg and the Art World of Our Time*. Garden City, NJ, 1980.

Varnedoe, Kirk, ed. *Jasper Johns: A Retrospective*. The Museum of Modern Art, New York, 1996.

———, ed. *Jasper Johns: Writings, Sketchbook Notes, Interviews*. The Museum of Modern Art, New York, 1996.

———. *Pictures of Nothing: Abstract Art Since Pollock*. Princeton, 2003.

Waldman, Diane, ed. *Ellsworth Kelly: A Retrospective*. The Solomon R. Guggenheim Museum, New York, 1996.

———. *Roy Lichtenstein*. The Solomon R. Guggenheim Museum, New York, 1993.

Weiss, Jeffrey. *Jasper Johns: An Allegory of Painting, 1955–1965*. National Gallery of Art, Washington, 2007.

Wood, Paul, et al. *Modernism in Dispute: Art since the Forties*. New Haven, 1993.

Wylie, Charles. *Brice Marden: Work of the 1990s: Paintings, Drawings, and Prints*. Dallas Museum of Art, 1998.